HPBooks®

Basic Guide To
CLOSE-UP PHOTOGRAPHY

Publisher: Rick Bailey
Editorial Director: Theodore DiSante
Editor: Vernon Gorter
Art Director: Don Burton
Book Assembly: Paul Fitzgerald
Typography: Cindy Coatsworth, Michelle Claridge

Published by HPBooks, P.O. Box 5367, Tucson, AZ 85703 (602) 888-2150
ISBN O-89586-352-9 Library of Congress Catalog No. 84-81029
© 1984 HPBooks, Inc. Printed in U.S.A.

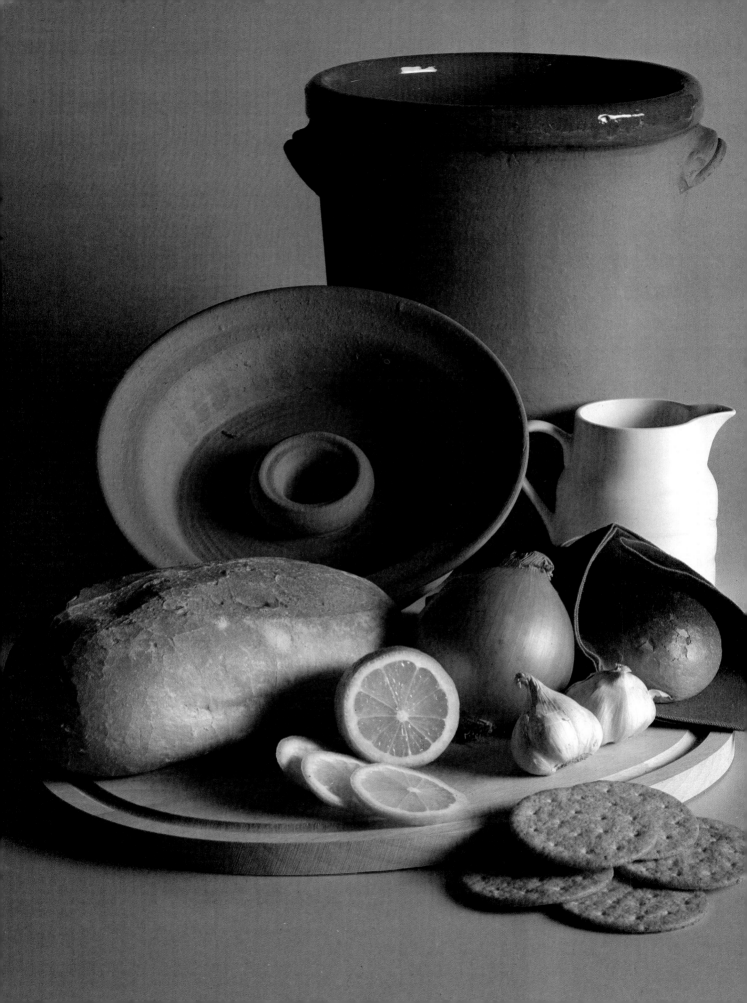

CONTENTS

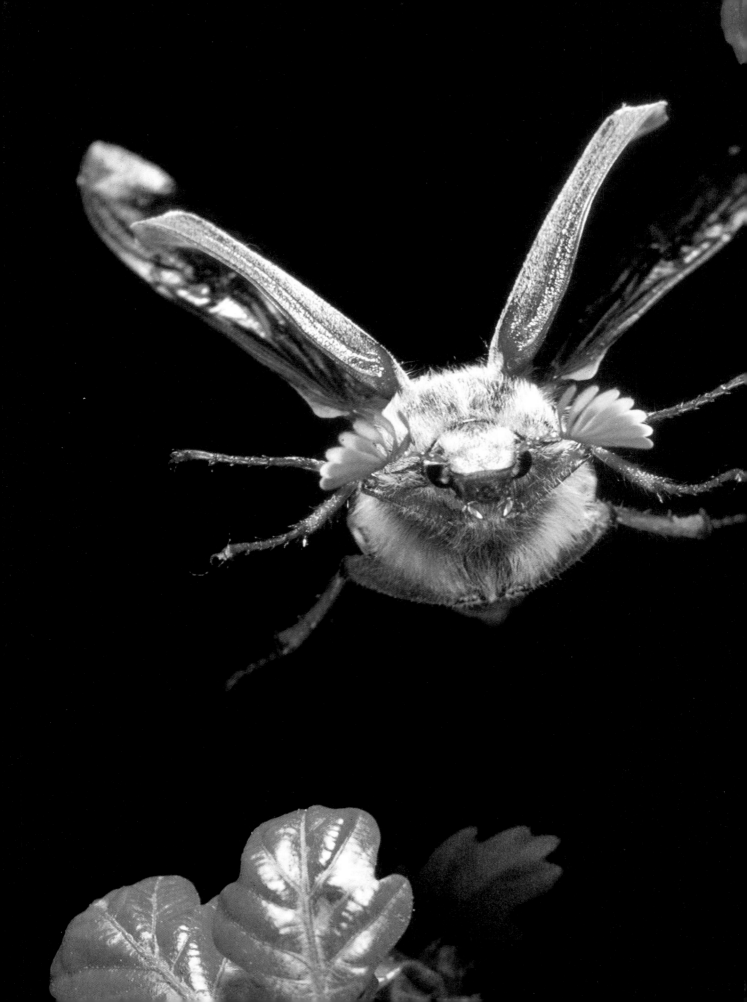

CLOSE-UP & MACRO PHOTOGRAPHY

Close-Up Lenses

To see detail in a small object, you bring the object close to your eyes. To photograph a close-up object, you have to bring your camera close to the object. There are several ways of achieving this. One of the easiest, both in terms of equipment and technique, is using *close-up lenses*.

Close-up lenses are simple lenses that are attached to the front of the camera lens. The combination enables you to focus the camera closer than would be possible with the camera lens alone. Basically, getting nearer the subject to be photographed provides a larger image on the film.

SLR ADVANTAGES

A single-lens reflex (SLR) camera is ideally suited for close-up photography. With it, you see in the viewfinder what the film is going to record—no matter how close the subject is to the camera lens. Camera viewfinders that don't "see" through the taking lens give you an inaccurate image outline when a subject is close to the lens. That's because the viewpoints of viewfinder and lens become increasingly different as a subject is brought close.

WHAT CLOSE-UP LENSES DO

Most standard 50mm camera lenses enable you to focus no closer than about 18 inches. With a close-up lens, or a combination of two of them, you can focus as close as a few inches from a subject.

As you'll see later in this book, there are several ways of getting larger images on film. However, for the beginning close-up photographer there are definite advantages to the use of close-up lenses. First, they provide one of the least expensive ways of achieving a larger image on film. Second, they are easy to use. Third, unlike other close-up methods, you need not increase camera exposure when you increase image size.

How They Work—Basically, a close-up lens works like a simple magnifying glass. To see an object larger, you hold a magnifying glass in front of your eye. You adjust the distance from the glass to the object until the object looks sharp.

Close-up lenses are made in different strengths for different image magnifications. They are also available with different filter-thread diameters so they can be used on most SLR cameras.

CLOSE-UP LENS (Diopters)	MINIMUM MAGNIFICATION (Camera Lens at Infinity)			MAXIMUM MAGNIFICATION (Camera Lens at Closest Focus)		
		Subject Distance			Subject Distance	
	M	mm	inches	M	mm	inches
1	0.05	1000	40	0.21	277	10.9
2	0.10	500	20	0.26	217	8.5
3	0.15	333	13	0.32	178	7.0
4	0.20	250	10	0.38	151	6.0
1+3	0.20	250	10	0.38	151	6.0
2+3	0.25	200	8	0.44	131	5.2
1+2+3	0.33	167	6	0.50	116	4.6
1+2+4	0.35	143	5	0.55	104	4.1
10	0.50	100	4	0.73	79	3.1

This table shows approximate minimum and maximum magnifications with combinations of diopter-rated close-up lenses and a 50mm camera lens. When using other camera lenses, follow this guideline: As the lens focal length doubles, so does the minimum magnification. The maximum magnification will not double, although it will increase.

The degree of enlargement is the ratio between the distance at which you would normally view the object and the focal length of the magnifying glass. Normal closest viewing distance for the unaided eye is about 10 inches or 250mm. If a magnifier has a focal length of 50mm, it will give an effective magnification of about five times because 250mm/50mm = 5.

Diopters—The strength of close-up lenses is defined in *diopters*. The power of a lens in diopters is the reciprocal of the focal length of the lens in meters (1m = 1,000mm). Thus, a lens having a focal length of 200mm has a strength of 1000mm/200mm, or 5 diopters

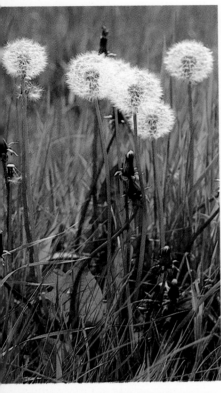

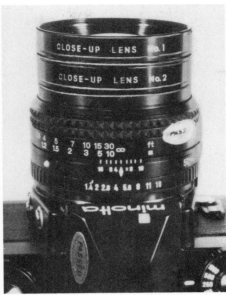

When stacking close-up lenses, put the one with the highest diopter rating closest to the camera lens.

The general view of dandelions, left, was shot with the SLR lens at its closest focus setting. Close-up lenses of different diopter ratings were added for the photos below. To make these two images life-size and larger, they were further enlarged at the reproduction stage.

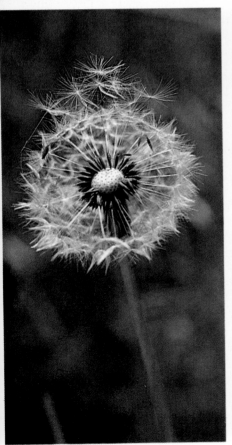

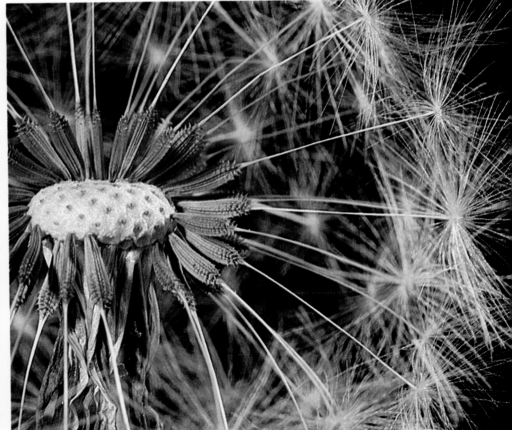

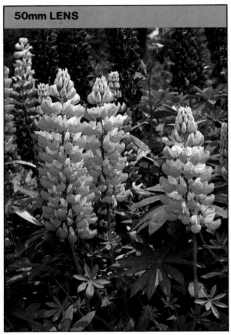

50mm LENS

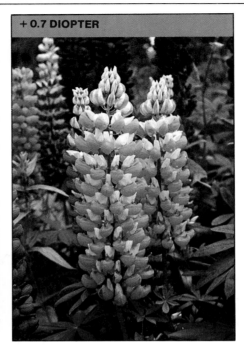

+ 0.7 DIOPTER

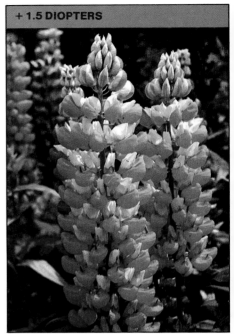

+ 1.5 DIOPTERS

The photo above was made with a standard 50mm lens. The other photos in the series were made with the close-up lenses indicated. The stronger the close-up lens used, the nearer you can bring the camera to the subject. The result is a larger image. The camera-lens focus was set at infinity for each photo. Exposure was identical for each shot.

Both photos were made with a 4.5-diopter close-up lens, so the magnification is the same. At *f*-8, the entire subject is sharp. At *f*-2, depth of field is inadequate.

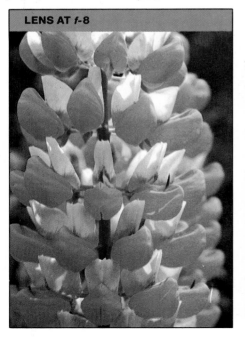

LENS AT f-8

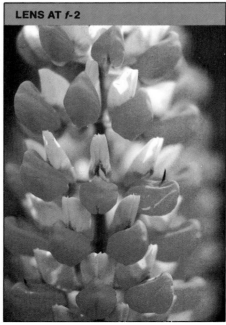

LENS AT f-2

Conversely, a 4-diopter close-up lens has a focal length of 1000mm/4 or 250mm. The higher the diopter value, the stronger the lens.

The easiest way to use close-up lenses is to convert their diopter value to focal length in mm. For example, a 4-diopter close-up lens has a focal length of 250mm. This tells you that an object 250mm (about 10 inches) from that lens will be recorded sharply on film when the camera-lens focusing ring is set to infinity.

Use Different Camera Lenses—You can use close-up lenses with camera lenses of different focal lengths. As long as the camera lens is focused at infinity, the subject distance will always be equivalent to the focal length of the close-up lens.

However, the longer the focal length of the camera lens, the higher the image magnification. For example, with a specific close-up lens, a 100mm camera lens set at infinity will give you an image twice as large as a 50mm lens set at infinity.

Change Camera-Lens Focus—By changing the camera-lens focusing ring to a setting closer than infinity, you can get a larger image with the same close-up lens. This is because you must now bring the subject nearer the close-up lens to get a sharp image.

The table on page 6 shows magnifications possible with a 50mm lens at different focus settings and with close-up lenses of different diopter values. (For a discussion and definition of

▶ The photographer is preparing to shoot the photos on these two pages. The camera is on a sturdy tripod. At the time of exposure, the handheld flash was aimed at the white card. This highlighted the flowers and brightened shadows. Exposure was balanced to also record the background lit by daylight.

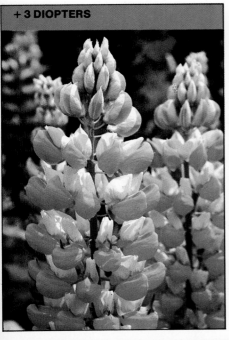

+ 3 DIOPTERS

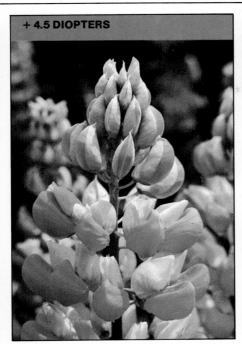

+ 4.5 DIOPTERS

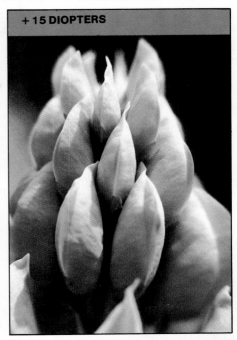

+ 15 DIOPTERS

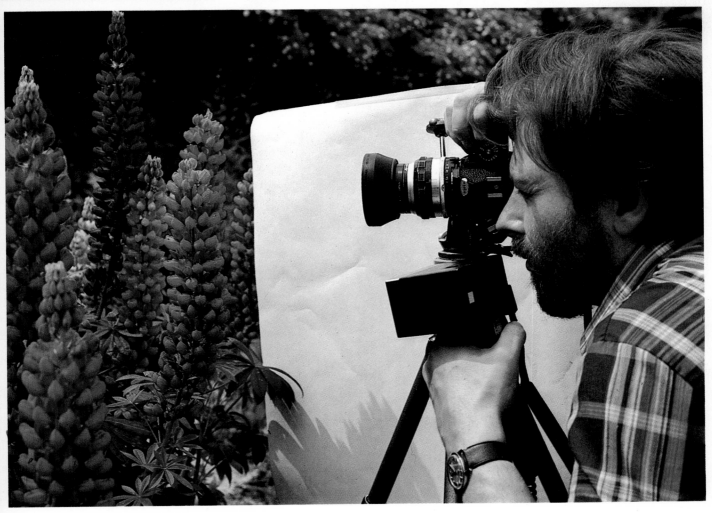

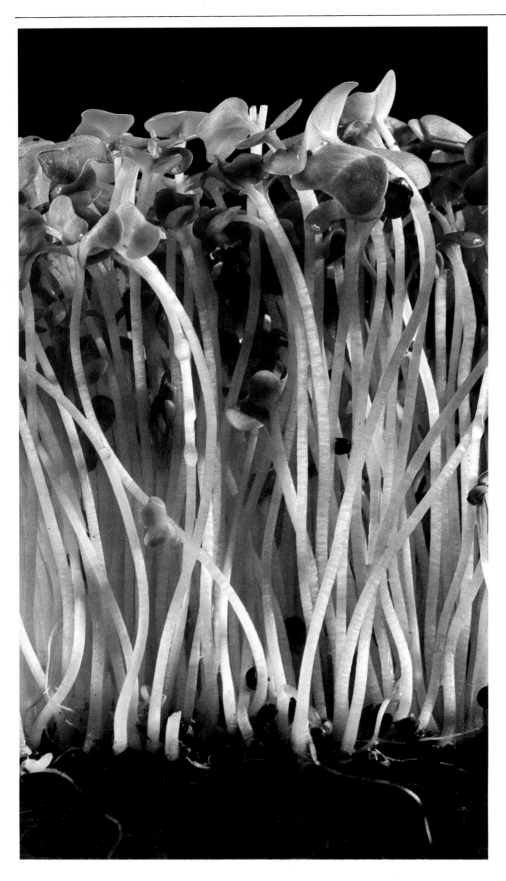

magnification, see page 12.)

Here, again, the SLR camera offers a distinct advantage. When using it you don't need to rely on tables o complex calculations to determine image size. You simply look through the viewfinder and see the resultan magnification.

Normal camera-focusing technique are not necessarily best when you're working in the close-up range. I close-up work, it's often best to move the camera back and forth to achiev sharp focus, rather than adjusting the lens setting.

LIMITATIONS

Although you can use close-up lenses with camera lenses of varying focal lengths, their use with wide angle lenses is not recommended The resultant image would not be o the highest quality. In fact, close-u lenses have some limitations with virtually all camera lenses. That's be cause they are not designed as part o the complex system of component that makes up a high-quality lens.

Overall image sharpness with close-up lens on a camera lens i never as good as with the camera len alone. Specifically, flatness of fiel deteriorates when close-up lenses ar used. The image is sharper at th center than at the corners, or vic versa. This problem is particularl noticeable with wide-angle lenses.

For optimum-quality images, it' best to use one of the other method of getting larger images, describe later. They rely on the camera len alone to achieve the enlarged image.

Use Small Lens Aperture—With close-up lenses, you'll get best imag quality when the lens is set to a smal aperture—such as f-11 or f-16. Thi reduces the effect of a curved imag field somewhat. A small lens apertur also gives more extensive depth o field. This is an important considera tion because depth of field is alway limited in close-up work.

◄ To record this impressive "forest" o watercress, two stages of magnificatio were used. With a close-up lens on th camera, a large film image was achievec This image was magnified further by con ventional enlargement.

Close-up photos are often of single objects. Composition is not as important as effective lighting. To make the subject stand out, select a simple, uncluttered background.

With a close-up lens, it's easy to photograph a single rose. It's no more difficult than shooting a whole rose garden. Frame and focus until you see what you want in the SLR viewfinder. Then shoot. No special exposure compensation is needed.

Limit Magnification—The stronger the close-up lenses you're using, the poorer will the image quality be. As a rule, it's not advisable to use a diopter power higher than 10. With a 50mm lens set at infinity, this gives a magnification of about 1/2 life size.

GENERAL TIPS

Following are some basic tips to help you get good photographs with close-up lenses:

Stacking Lenses—You can "stack" close-up lenses to get higher magnifying power. For example, using a 1-diopter lens together with a 3-diopter lens gives a total power of 4 diopters. When you use two lenses in this manner, you'll get the best optical quality by placing the stronger lens closer to the camera lens.

Don't use more than two close-up lenses at the same time. The magnification you gain won't be worthwhile because the loss in image quality will be too great.

Get Everything Sharp—Try to place the most important subject parts in a plane perpendicular to the lens axis. Remember, depth of field is always limited in close-up photography. To get as much as possible sharp, keep image parts at the same distance from the lens. If the subject is not flat, focus on the most important part and stop the lens down as far as possible.

Avoid Image Blur—Any blur due to camera vibration or movement is enlarged along with the image. If you can't use a fast shutter speed—such as 1/250 second or faster—put your camera on a sturdy tripod.

Avoid subject movement, too. This is particularly important when you're shooting outdoors. Flowers and foliage move constantly, even in a slight breeze. Shield the subject from the wind as much as possible. Wait for still moments and expose then. Or, if possible, move the subject indoors, away from the wind.

Use Flash—You can avoid both camera and subject movement by using electronic flash. Most electronic flash has a duration of about 1/1000 second or shorter. Automatic flash units at close range can give a flash duration as short as 1/30,000 second.

Bracket Exposures—There are many possible variables in close-up photography. Correct exposure is affected differently by different methods of magnifying the image, as you'll see later. Lamp and flash reflectors behave differently at close range than at the distance for which they were designed. Flash guide numbers are not necessarily reliable at close range.

To be sure to get a well-exposed photo, make several exposures. Vary them in half-steps from about two steps under to about two steps over the exposure you consider might be optimum.

Cleanliness is Important—Be sure the subject is clean. Remember, any dust or other foreign particles will be enlarged along with the subject.

Extension Tubes

Like close-up lenses, *extension tubes* enable you to focus at shorter distances than the 18 inches usual with a standard 50mm camera lens. Extension tubes are simple extenders you insert between the SLR camera body and lens. As with a close-up lens, the closer focusing distance results in a larger image on film. But that's about where the similarity with close-up lenses ends.

DEFINITIONS AND FORMULAS

Extension tubes—and extension bellows, discussed in the next section—enable you to get a larger image on film than you would without them.

Image *magnification* (M) is the ratio of image size (I) to subject size (S). Therefore:

$$M = I/S$$

For example, if an object two inches long is reproduced on film one inch long:

$$M = 1 \text{ inch}/2 \text{ inches} = 1/2 \text{ or } 0.5$$

Extension tubes can be used singly or in combination. A total extension equal to the focal length of the lens results in a life-size image when the lens is set to infinity. To maintain the camera's automatic aperture control you need *automatic* extension tubes.

Similarly, if an object 1/4 inch long is reproduced on film one inch long, the magnification is 4.

Image magnification is also dependent on the focal length (F) of the lens and extension (X) between lens and camera. The following formula shows the relationship:

$$M = X/F$$

Example: With a 50mm lens set to infinity and an added extension of 50mm:

$$M = 50mm/50mm = 1$$

With a 100mm lens set to infinity and the same 50mm extension:

$$M = 50mm/100mm = 1/2 \text{ or } 0.5$$

The above formula can also be stated as:

$$X = M \times F$$

This enables you to determine what added lens extension you need to achieve a specific image magnification. Suppose you're using a 100mm lens and want an image magnification of 0.25 (1/4). Use the formula to calculate the added lens extension:

$$X = 0.25 \times 100mm = 25mm$$

This tells you that you must add a 25mm extension between the camera body and the lens, which is set to infinity.

Close-Up Photography—This term is used for photography at greater magnification than is possible with most unaided conventional camera lenses. The close-up range extends from an image magnification of about 0.1 (1/10) to 1. The magnification of 1 is also called *life-size*.

To make close-up photos, you can use either supplementary close-up lenses, extension tubes or special "macro" lenses. A discussion of these lenses starts on page 22.

Macro Photography—At magnifications greater than 1, you enter the field of *macro photography*. For this, you typically need extension tubes or—more often—bellows. The latter is described in the next section.

SET OF TUBES

Extension tubes come in sets. You can use the tubes singly or in combination. The shortest tube is usually about 7mm long. The built-in focus travel of a standard 50mm camera lens is a little more than 7mm. This means that a complete set of tubes gives you a selection of continuous magnifications.

A typical set of tubes also usually contains one combination that gives an extension of exactly 50mm. This provides a double extension for a standard 50mm lens. As the formula presented earlier shows, this makes possible a life-size reproduction of the subject on film when the lens is set to infinity. When the lens is set to its closest focus, maximum magnification is a little bigger than life-size.

Automatic Extension Tubes—These are designed so that the automatic diaphragm of the lens works normally. You can view the subject at the widest lens aperture. Just before exposure, the lens stops down to the predetermined *f*-stop.

Manual Extension Tubes—They are available for many of the older SLR cameras. You must close the lens aperture manually before making the exposure.

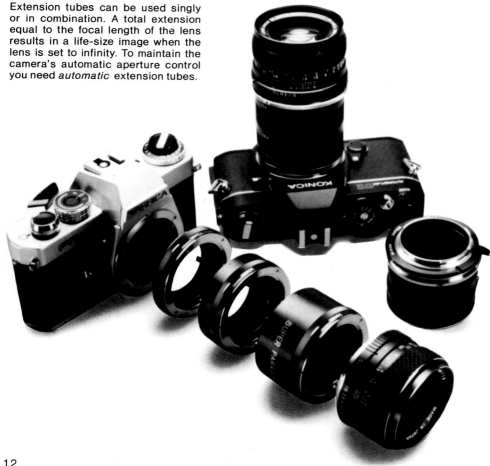

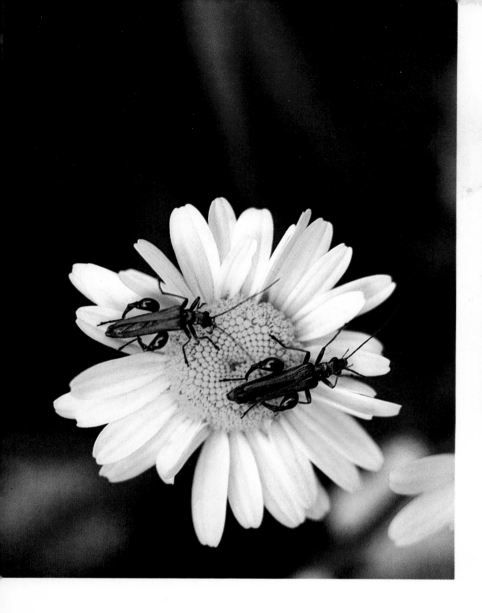

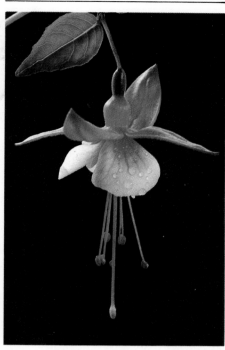

▲ The natural background behind this flower was busy and confusing. To separate the bloom, the photographer placed a plain card behind it.

◄ A 50mm lens used with a 25mm extension tube resulted in a half life-size image in the 35mm slide. In this reproduction, that image has been enlarged considerably more.

Helicoid Extension Tubes—A screw-thread adjustment provides continuously variable extension. This adds versatility by enabling you to get a continuous range of magnifications with one tube.

ADVANTAGES

To make close-up photographs of the best quality, you'll want to go beyond the close-up lenses discussed earlier. Following are some reasons why extension tubes are superior:

Image Quality—With extension tubes, you use only the camera lens. You don't add simple auxiliary lenses that could degrade the superior image quality produced by a fine lens.

Magnification Range—The magnification practical with close-up lenses is limited. Extension tubes enable you to achieve quality close-up photos, in addition to macro photographs at magnifications of life-size and greater.

LENS SELECTION

Lenses of different focal lengths have different effects with extension tubes. Following are the two most important considerations in choosing a lens:

Image Magnification—As the formula on page 12 shows, the shorter the focal length of the lens, the greater the possible image magnification with a set of extension tubes. For example, to produce a life-size image, the added extension must equal the focal length of the lens when the lens is set to infinity. This means that a 100mm lens requires twice the extension needed by a 50mm lens to achieve the same image magnification.

A 100mm extension with a 100mm lens gives a life-size reproduction. The same extension with a 50mm lens will give an image magnification of 2.0. So, to get the highest possible magnification from a specific set of tubes, you should use the shortest lens you have. However, there are limitations to this, as indicated below.

Working Distance—The distance between the subject and the front of the camera lens is called the working distance. When this distance is very small, photography becomes difficult. You are limited with the placement of lights or reflectors.

At the same image magnification, a lens of longer focal length gives more working distance. Of course, you'll need a longer extension to achieve the same magnification. And maximum magnification possible will be reduced.

REVERSING RING

Lenses intended for normal camera use are designed for best optical performance when focused at distances of several feet to infinity. When used at magnifications of 1.0 or greater, they often perform best if *reversed*. You attach the *front* of the lens to the camera body. To mount the lens this way, use a *reversing ring*.

A reversing ring screws into the filter-mounting thread on the lens front. The other end of the ring has a mount that fits onto the front end of extension tubes, bellows or camera body.

When a regular camera lens is mounted in reverse, its built-in focus control doesn't work. This isn't important because the best way to focus in the macro range is to move the entire camera assembly back and forth.

▶ To make this image, the photographer used an extension of 50mm on a 50mm lens. This gave life-size magnification on the 35mm slide. The quality was good enough to enable us to enlarge the image to the size reproduced here. The ladybug is reproduced 2-1/4-inches long.

SHOOTING CLOSE-UPS WITH EXTENSION TUBES

For the photo below, the lens was set at its closest focusing distance. For the photos made with extension tubes, the lens was set to infinity.

TO ESTIMATE EXTENSION NEEDED FOR SPECIFIC MAGNIFICATION

When X is the added extension between lens and camera, M is the image magnification and F is the focal length of the camera lens:

$$X = M \times F$$

Example: When you want a magnification of 1.5 with a 50mm lens set to infinity:

$$X = 1.5 \times 50mm = 75mm.$$

You must add 75mm of extension with extension tubes or bellows.

TO ESTIMATE MAGNIFICATION ACHIEVED WITH SPECIFIC EXTENSION

Use this formula: $$M = X/F$$

Example: When using a 50mm lens set to infinity and an added 25mm extension:

$$M = 25mm/50mm = 1/2 = 0.5$$

Magnification is half life-size when the lens is set to infinity. As you set the lens focus to closer distances, magnification increases. With a typical 50mm standard lens, maximum focus travel is about 7mm. With a 50mm macro lens, maximum focus travel is 25mm.

STANDARD 50mm LENS

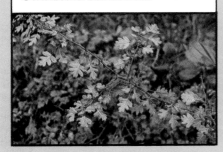

PLUS 8mm EXTENSION TUBE (M=0.16)

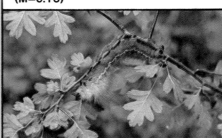

PLUS 14mm EXTENSION TUBE (M=0.28)

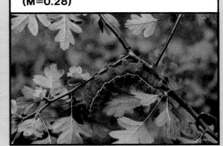

PLUS 27.5mm EXTENSION TUBE (M=0.55)

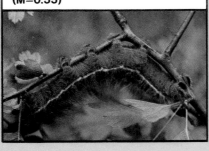

PLUS 2 EXTENSION TUBES TOTALING 41.5mm (M=0.83)

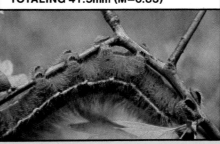

PLUS 3 EXTENSION TUBES TOTALING 49.5mm (M=0.99)

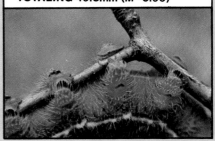

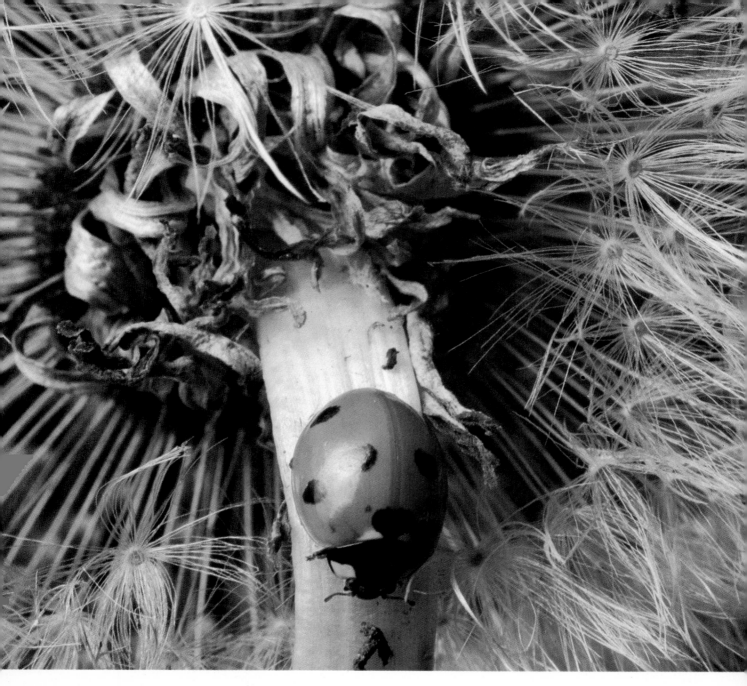

Some manufacturers produce versing rings that enable you to tain automatic aperture control. sk your photo dealer for details.

XPOSURE-INCREASE FACTOR
With the close-up lenses described the previous section, you need not ake exposure compensations for lage magnification. It's not that mple with extension tubes. As the mera lens moves farther from the m plane with increased magnifica-on, the image becomes dimmer. To mpensate for this, you must in-ease exposure.

The required exposure compensa-on is based on image magnification, not on the extension used. For example, a 50mm extension with a 50mm lens set to infinity gives a life-size image. This calls for an exposure increase factor of 4X, or two *f*-stops. The same 50mm extension with a 100mm lens gives a magnification of 1/2 (1/2 life-size). This would require an exposure increase factor of only 2X, or one *f*-stop.

You can determine the required exposure-increase factor (EF) by using the formula:

$$EF = (M + 1)^2$$

For example, if the image magnification is 1 (life-size):

$$EF = (1 + 1)^2 = 2^2 = 4$$

This means you must increase the exposure time by 4 times. Alternative-ly, you could open the lens aperture by two stops. However, in macro work you don't generally want to open the lens aperture and decrease the already limited depth of field.

TTL Metering—SLR cameras featur-ing TTL (through-the-lens) metering compensate automatically for light fall-off at the film plane with increased magnification. Therefore, you need not make any manual exposure adjustments. For more details, see *Lighting Small Objects,* page 28.

Extension Bellows

Extension bellows provide the ultimate step into the wonderful world of macro photography. Basically, they perform the same function as extension tubes. However, a bellows gives more extension and therefore a greater range of magnifications. You attach a bellows between camera body and lens, just as you do extension tubes.

ALL THE MAGNIFICATION YOU NEED

Using a suitable short-focal-length lens, you can achieve any *useful* magnification with a bellows. You can also enter the realm of *useless* magnification—commonly called *empty magnification*. It occurs when an increase in image magnification no longer provides additional image detail or information.

Empty magnification sets in at a certain magnification for a variety of optical and physical reasons. The important thing to remember here is that extension bellows can give you all the magnification you can use.

For example, a single bellows for a 35mm SLR can give an extension of up to 200mm. This enables you to achieve a magnification of 4.0 with a standard 50mm lens. With a 35mm lens, you can achieve a magnification of about 6.0. By using a shorter lens and combining two bellows, you easily reach the practical limit where empty magnification sets in.

It's important to remember that empty magnification is not the only cause of image-quality loss. The photographer's care and skill play an important part in maintaining quality. The higher the magnification, the more likely the image is to suffer from blur caused by equipment vibration or inaccurate focusing.

A bellows can serve another useful purpose. You may need additional working space between subject and lens at a specific magnification. A longer-focal-length lens gives you the added working space. A long bellows provides the extension needed to maintain the required magnification.

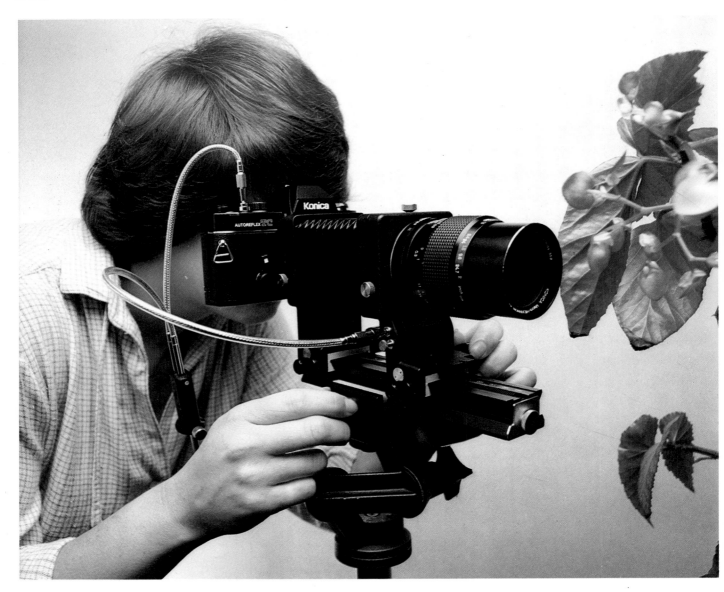

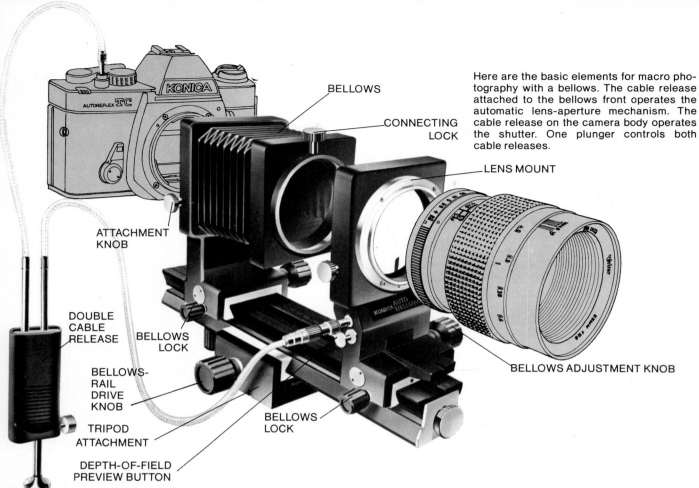

BELLOWS

CONNECTING LOCK

Here are the basic elements for macro photography with a bellows. The cable release attached to the bellows front operates the automatic lens-aperture mechanism. The cable release on the camera body operates the shutter. One plunger controls both cable releases.

LENS MOUNT

ATTACHMENT KNOB

DOUBLE CABLE RELEASE

BELLOWS LOCK

BELLOWS-RAIL DRIVE KNOB

TRIPOD ATTACHMENT

BELLOWS LOCK

DEPTH-OF-FIELD PREVIEW BUTTON

BELLOWS ADJUSTMENT KNOB

AMERA LENSES

Listed below are various lenses, ogether with a brief explanation of ow they work with bellows.

8mm or 36mm Wide-Angle Lens— void lenses having a maximum lens perture of *f*-2 or wider. An *f*-2.8 lens f good optical quality should work ell. Even if you were to stop both nses down to *f*-11, the *f*-2.8 lens ould generally give a better image nan a faster lens.

Wide-angle lenses are not designed o be used at large extensions and ery close to the subject. To get the est from the lens, reverse it on the ellows, using a reversing ring.

tandard 50mm Lens—Lenses with a aximum aperture of *f*-2 or wider are nlikely to give the best results. The esign of a slower lens is more suitable or macro work—even when you stop he lens down. At magnifications of bout 1.0 and greater, you'll get the est image quality with the lens eversed.

Set magnification by adjusting the bel- ws length with the lens set to infinity. To cus, move the entire assembly toward or vay from the subject. The bellows shown ere has a movable rail for focusing.

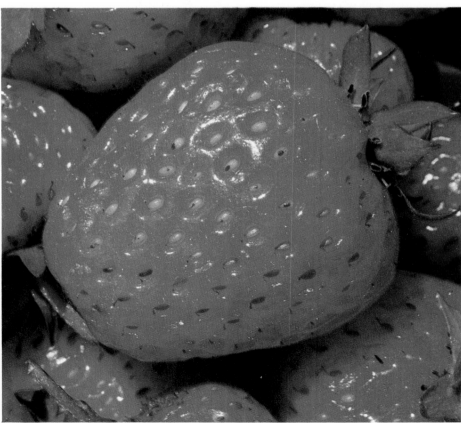

The strawberries were in a half-filled straw-colored basket. Main illumination came from diffused sunlight. The sides of the basket acted as reflectors, brightening shadows.

50mm or 55mm Macro Lens—For details about macro lenses, see the next section. Macro lenses are designed for use over a wide range of distances—from near to far. Therefore, they produce fine results close-up. However, at magnifications of 2.0 or greater, it is often best to reverse even a macro lens.

100mm or 105mm Macro Lens—Because of their longer focal lengths, these lenses give more working distance but require greater bellows extension for a given magnification.

85mm to 135mm Telephoto Lens—These lenses give ample working distance but require a longer bellows extension for a given magnification. Telephoto lenses of different designs perform differently in the macro range. To determine whether a lens is suitable for your needs, try it.

200mm Telephoto Lens or Longer—Such lenses are rarely suitable for macro work because of the extreme bellows length needed and the very limited depth of field they offer.

Zoom and Macro Zoom Lens—These versatile lenses can be used for macro work but rarely give as good definition at the edge of the image field as fixed-focal-length lenses.

Reversing Ring—Rings designed for reversing lenses of various mount designs are available. Ask your photo dealer for details. See also page 14.

STABILITY

When you photograph in the macro range, you need the utmost in equipment stability. Use a sturdy tripod. Be sure the camera/lens/bellows assembly is rigid. Avoid working in areas prone to vibration from passing traffic, machinery or other causes.

LIGHTING

At high magnification, you lose a lot of light at the film plane. Therefore, you need bright illumination, both to make focusing easier and to avoid unduly long exposure times. For more information, see *Lighting Small Objects,* page 28.

EXPOSURE

As mentioned in the section on extension tubes, when you photograph in the close-up and macro range you must compensate exposure for light loss in the camera system. The higher the image magnification the more additional exposure you need. For details, see pages 20 and 33.

FOCUSING

In macro work it is generally easiest to set the camera extension first for the magnification you want. Then focus by moving the entire camera assembly back and forth. Some bellows

▶ The 15mm-long insect was recorded life size on film. A low light from the left emphasized the texture and shape of the creature. A reflector on the right lightened the shadows. The black background provides clean outline for the subject.

▼ The tungsten light above the camera was used for focusing and composition only. was turned off during the flash exposure. Two flash units were used—one on each side of the camera. To give maximum emphasis to the flower's outline, the photographer added a black card as background. For each photo of the flower, the camera lens was set to infinity.

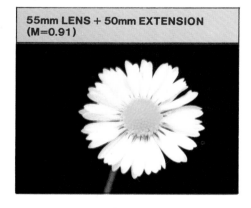

55mm LENS + 50mm EXTENSION (M=0.91)

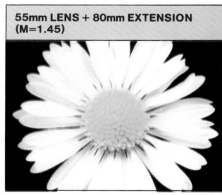

55mm LENS + 80mm EXTENSION (M=1.45)

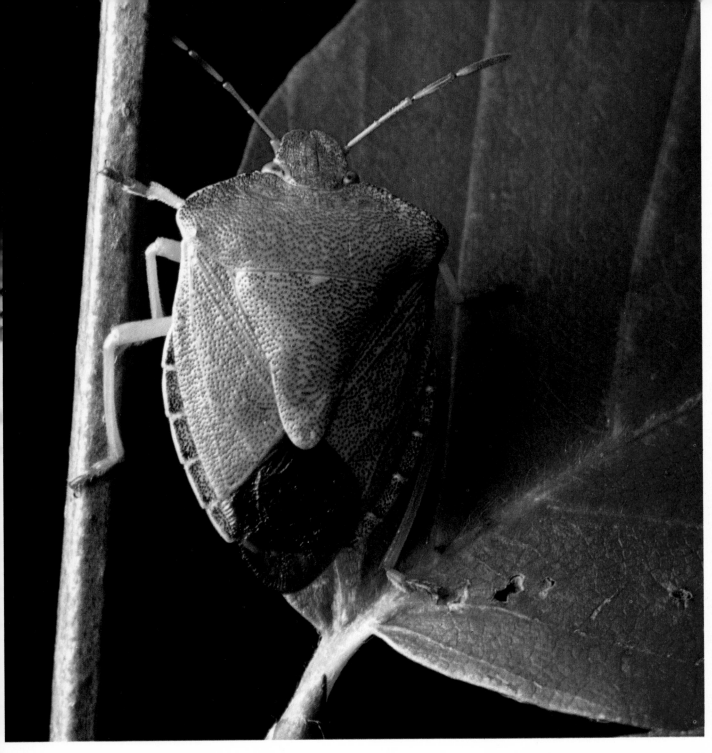

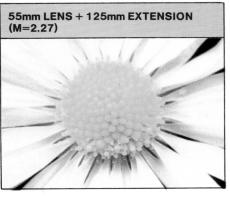

**55mm LENS + 110mm EXTENSION
(M=2.0)**

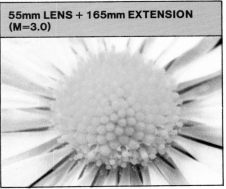

**55mm LENS + 125mm EXTENSION
(M=2.27)**

**55mm LENS + 165mm EXTENSION
(M=3.0)**

assemblies are designed so you can move the entire camera assembly back and forth along the bellows rail without changing the extension.

LIMITATIONS

Bellows are the ultimate tool for making quality photos in the macro range. However, bellows also have some limitations. For example, it's virtually impossible to use a bellows macro setup handheld. A tripod is essential.

Some bellows assemblies do not permit you to use the automatic aperture-setting mechanism of your camera. However, some bellows can be used with double cable releases. One cable operates the automatic aperture-closing mechanism, and the second works the shutter.

EXPOSURE-INCREASE FACTOR

Adding extension to a lens to get more magnification necessitates an increase in exposure. You can calculate this increase with a simple formula. If you use TTL metering, exposure compensation for added extension is automatic and you need make no calculations.

The exposure increase factor (EF) is related to magnification, not lens focal length. To determine EF at a specific magnification (M), use this formula:

$$EF = (M + 1)^2$$

Example: When you're working at a magnification of 3:

$$EF = (3 + 1)^2 = 4^2 = 16$$

To allow for the extension used, you must increase exposure time by 16 times or, as shown by the table, open the lens aperture four exposure steps.

USING EXPOSURE-INCREASE FACTOR

For correct exposure, multiply the exposure time indicated by a meter reading by the exposure-increase factor (EF) for the magnification (M) you're using. Alternatively, open the lens by the number of steps indicated. The steps are given to the nearest 1/3 f-stop. To ensure accurate exposure, bracket exposures.

M	EF	STEPS
0.2	1.4	1/2
0.3	1.7	2/3
0.4	2.0	1
0.5	2.3	1-1/3
0.6	2.6	1-1/3
0.7	2.9	1-1/2
0.8	3.2	1-2/3
0.9	3.6	1-2/3
1.0	4.0	2
1.25	5.0	2-1/3
1.5	6.3	2-2/3
1.75	7.6	3
2.0	9.0	3
2.25	10.6	3-1/2
2.5	12.3	3-2/3
2.75	14.1	3-2/3
3.0	16.0	4

▶ With the use of bellows extension, this bloom almost filled the 35mm film frame. Flash light, bounced from a large umbrella, produced the soft, uniform illumination.

APPROXIMATE MAGNIFICATIONS WITH VARIOUS LENSES AND EXTENSIONS

UNREVERSED LENS (At Infinity)	BELLOWS EXTENSION					
	35mm	50mm	85mm	100mm	135mm	200mm
	APPROX. MAGNIFICATION					
35mm	1.0	1.4	2.4	2.9	3.9	5.7
50mm	0.7	1.0	1.7	2.0	2.7	4.0
85mm	0.4	0.6	1.0	1.2	1.6	2.4
100mm	0.4	0.5	0.9	1.0	1.4	2.0
135mm	0.3	0.4	0.6	0.7	1.0	1.5
200mm	0.2	0.3	0.4	0.5	0.7	1.0

To find the magnifications achieved with other lens/extension combinations, see the formula in the box on page 14.

PUPILLARY MAGNIFICATION FACTOR

The accompanying formula and table for exposure correction apply to lenses near 50mm focal length. Exposure correction for lenses of telephoto and wide-angle design is more complicated. This is because of the *pupillary magnification factor* of such lenses. This is the difference between the amount of light transmitted at a specific aperture when a lens is used in the normal way and when it is used reversed.

Unless you're using TTL metering, you must allow for this factor when calculating exposure. This involves the use of further formulas.

With telephoto lenses, the pupillary magnification factor is usually less than 1. It calls for a greater exposure increase than indicated by the accompanying formula and table. With wide-angle lenses, the factor is generally greater than 1. This calls for a smaller exposure increase than the formula and table indicate.

For more details on the pupillary magnification factor and the formulas that define it, please see *SLR Photographers Handbook,* also published by HPBooks.

If you use telephoto or wide-angle lenses for close-up or macro photography without allowing for the pupillary magnification factor, be sure to bracket exposures liberally.

Macro Lenses

So-called *macro lenses* made for SLR cameras provide increased convenience and quality to the close-up photographer. The most common macro lens has a focal length of 50mm. Macro lenses with focal lengths of 55mm, 80mm, 100mm and 105mm are also available.

These lenses—sometimes also called *micro lenses*—have a longer built-in focus travel than standard camera lenses. They enable you to focus on a subject close enough to yield an image magnification of 0.5 (1/2 life-size). With an extension tube equal to half the lens focal length, the magnification possible goes up to life-size. With bellows, further magnification is possible.

VERSATILITY

Macro lenses are not intended solely for close-up and macro photography. Because of special optical design and physical construction, they are also suitable for use with subjects at infinity and intermediate distances. Unlike conventional camera lenses, they provide excellent optical quality and flatness of field throughout this full range.

These two photos show the extended focus travel of a macro lens. In the top photo, the lens is focused at infinity. In the bottom photo, it is fully extended to give a magnification of 0.5. Macro lenses are designed to give good flatness of field and no linear distortion. This is important when photographing rectangular shapes containing fine detail toward the corners, like postage stamps.

At magnifications of about 2.0 and higher, it is advisable to reverse the lens for optimum performance. However, an unreversed macro lens gives better image quality than an unreversed standard camera lens.

Macro lenses are particularly convenient if you frequently switch from shooting distant subjects to photographing close-ups. You need carry only the one lens. The automatic camera functions work in exactly the same way as with other camera lenses.

A macro lens with focal length of 50mm or 55mm can double as a standard camera lens.

A 100mm or 105mm macro lens can serve as a short telephoto lens in addition to its function in the close-up range. For example, it makes an ideal lens for portraiture. The longer macro lens is also useful when you want a

Here are some of the macro-lens options you have. For high-quality images at magnifications up to 2 or 3, use a 50mm or 100mm macro lens, with additional extension when needed. For higher magnifications, a 20mm bellows macro lens on a bellows is more convenient because the required extension is much smaller. Use macro zoom lenses only when total sharpness toward the corners and absence of linear image distortion are not essential.

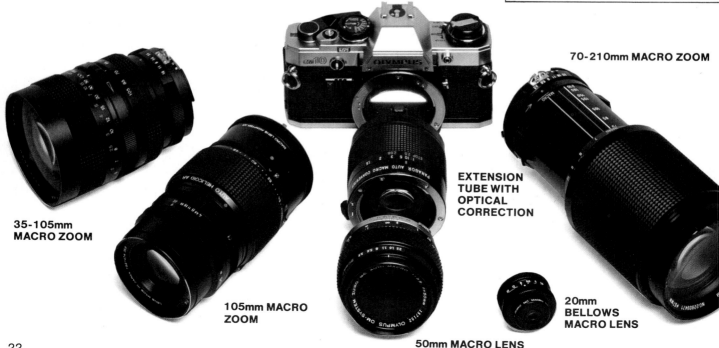

70-210mm MACRO ZOOM

35-105mm MACRO ZOOM

105mm MACRO ZOOM

EXTENSION TUBE WITH OPTICAL CORRECTION

20mm BELLOWS MACRO LENS

50mm MACRO LENS

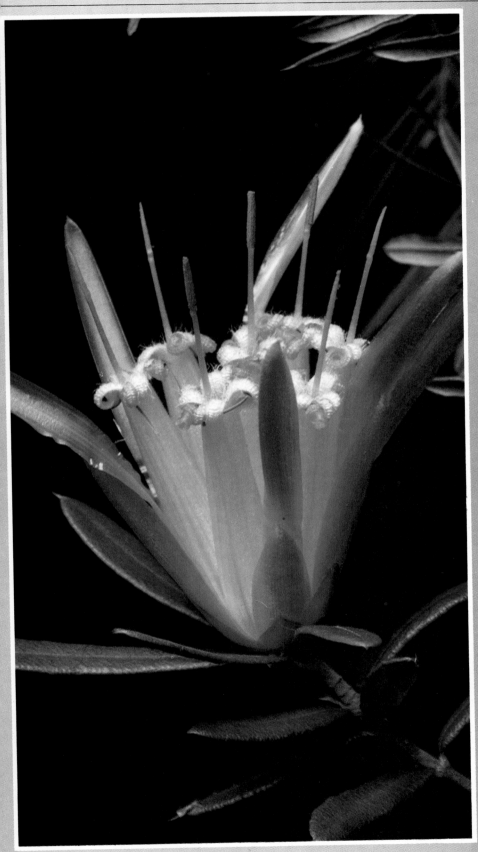

This is a mountain devil, a flower native to Australia. The film image was one half life-size. This was achieved with a macro lens at full extension. The image has been enlarged here eight times, recording the flower at a magnification of 4.

greater working distance than the 50mm or 55mm lens can offer at the same magnification.

LENS APERTURE

To achieve the necessary optical design, the maximum aperture of a macro lens is smaller than that of a conventional camera lens. For a 50mm macro lens, maximum apertures of f-2.8 or f-3.5 are common. This is a compromise you can readily accept unless you do a lot of work in dim light.

Macro lenses have a smaller minimum lens aperture than conventional camera lenses. They generally can be

A release button on this macro zoom lens allows you to focus closer than you would normally be able to. You can work at any focal length within the range of the lens.

On this Vivitar 70-210mm zoom lens, macro focusing is possible only at the 210mm setting. Maximum image magnification is about 1/2 (0.5). At that magnification, the subject-to-lens distance is 290mm (about 11-1/2 inches).

stopped down to *f*-32. This is to satisfy the extra need for depth of field in the close-up range.

BELLOWS MACRO LENS

The lenses discussed so far are not, in the strictest sense, "macro" lenses. Unaided and unreversed, they are designed for use at distances from infinity to a close enough range for magnifications of about 1/2 life-size. This excludes the macro range. Only with added extension—such as extension tubes or bellows—can a macro lens work in the macro range. The function of these lenses might be better understood if they were called *close-focusing* lenses.

True macro lenses are designed specifically for achieving magnifications greater than life-size. Such lenses have no built-in focusing capability and must be used on a bellows.

A 135mm bellows macro lens is useful when a high magnification is not needed but adequate working distance is important. To achieve high magnifications, use a short macro lens such as a 20mm.

Bellows macro lenses are specifically designed for macro work and need never be reversed to achieve optimum quality.

Good Substitutes—Enlarging lenses make excellent bellows macro lenses. So do movie camera lenses. Each type is designed to give a flat image field. However, for best quality in the macro range, each should be reversed on the bellows.

EXPOSURE COMPENSATION

The exposure compensation rule that apply to the use of extension tubes and bellows apply to macro lenses with built-in extension, too. Remember, exposure increase depends on image magnification and not camera extension. The information in the box on page 20 applies.

▶ This reproduction shows a peacock butterfly at a magnification of about 4. On the original slide, the magnification was half life-size. The black background keeps the viewer's attention on the subject.

MACRO LENSES AND WHAT THEY DO

55mm MACRO LENS

You can fill the frame with a small subject like this butterfly.

The built-in extension enables you to get a half life-size image on film.

105mm MACRO LENS

You can get the same image size as with the 55mm lens, but at a greater working distance.

The built-in extension enables you to get a half life-size image.

VIVITAR 70-210mm MACRO ZOOM

With the lens set at lower than 210mm focal length, macro focusing is not possible.

At the 210mm setting the lens has macro-focusing capability. You can get magnification of almost half life-size.

Macro lenses between 50mm and 105mm focal length are designed to give excellent image quality at half life-size. The longer lenses give greater working distance at the same magnification. This is useful when photographing timid creatures or when room is needed for lights. A macro zoom is versatile but does not give the good image quality of a fixed-focal-length macro lens.

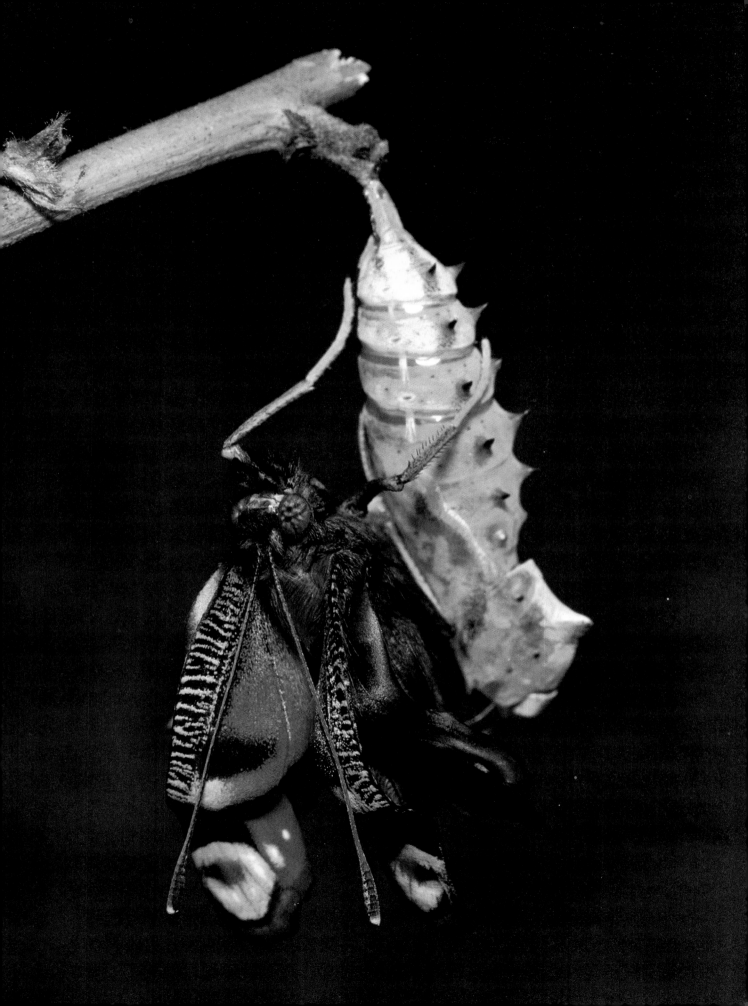

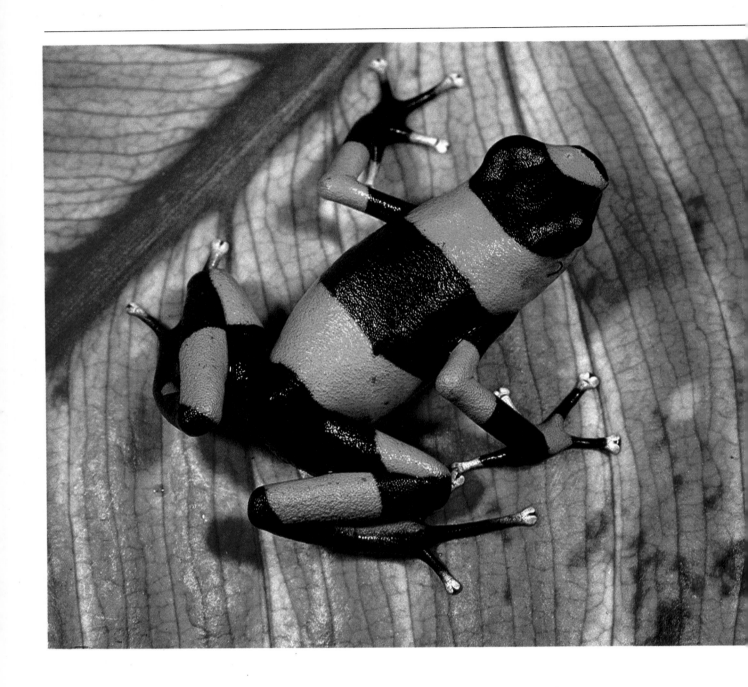

With through-the-lens (TTL) metering, no exposure calculations are necessary. The camera automatically compensates for any light loss due to camera extension. With a camera/flash system that reads the brightness of the image at the film plane, you also need not make any exposure compensation. For exposure with other types of electronic flash, see *Lighting Small Objects,* page 28.

MACRO-ZOOM LENS

Two *macro-zoom* lenses are shown in the photograph on page 22. Most macro-zoom lenses can be used as either *zoom* or *macro* lenses—not both at the same time. For close-up work, you set the lens to the "macro" mode.

Zoom lenses are often a compromise in image quality. This is especially true when you use this type of lens in the macro mode. Unless you need the zoom function in the same lens, it's advisable to avoid zoom lenses for macro work—especially if you're after high-quality images.

◄ This exotic frog was photographed with a 55mm Micro-Nikkor lens. Notice that Nikon macro lenses are called *micro* lenses. Illumination came from a twin-headed macro flash, mounted on a bracket with the camera. The lights produced extensive highlights on the frog, bringing out its skin texture.

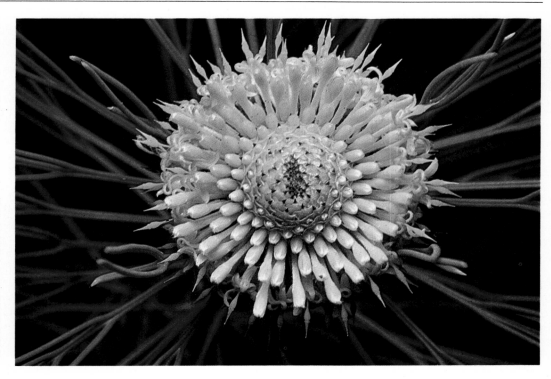

► Shooting this dramatic close-up of a small flower was remarkably simple. No tripod, lens extension, elaborate lighting or special background were needed. The photographer used a 55mm macro lens at full extension. A single flash, attached to a camera bracket, provided frontal illumination. At such close range, illumination falls off very rapidly with distance. Therefore, the black background happened almost automatically.

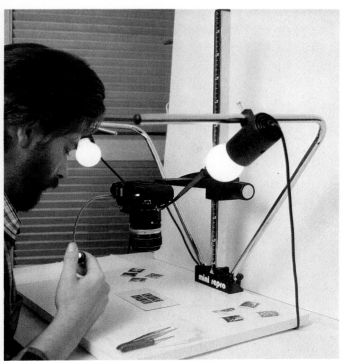

The more permanent the setup, the more consistent your results. This copying system is ideal for photographing flat subjects such as postage stamps. The lights can be positioned for even illumination or adjusted for different effects. When appropriate, one of the lights can be switched off. The assembly is sufficiently rigid to permit exposures of several seconds—if it is in a vibration-free area. For best image quality with flat subjects, use a macro lens.

Lighting Small Subjects

Lighting techniques used in conventional photography are rarely adequate for close-up and macro work. Especially in the macro range, making life-size and larger images, you need the brightest illumination you can get.

There are several reasons for this. The extra camera extension used causes light loss at the film plane, as explained earlier. The need for a small lens aperture, to ensure adequate depth of field, reduces the brightness of the image further. You want to keep exposure times as short as possible to avoid image blur due to camera movement or vibration during the exposure.

When the camera lens is close to the subject, the space you have for lights is limited. Generally, you will use only one light, augmented perhaps by a reflector. It's essential that this one light gives bright and concentrated illumination to the subject.

ELECTRONIC FLASH

In many ways electronic flash is the most suitable form of illumination for close-up and macro photography.

Advantages—Electronic flash provides bright illumination for a short duration. When used in the manual mode, electronic flash generally has a duration of about 1/1,000 second. In the automatic mode, the duration can be as short as 1/30,000 second.

The flash is usually bright enough to enable you to use a small lens aperture.

Electronic flash has the same color characteristics as average daylight. This means you can use daylight balanced film—the kind you use for all your outdoor shooting—for your close-up photography, too.

Electronic flash has another advantage especially important for the macro photographer—it generates virtually no heat. By contrast, many tungsten lamps get so hot that they might damage camera lens, bellows, subject, or all of these, when placed close to them.

Because of the short duration of the flash, you can make close-up flash pictures with the camera handheld. It's best if the flash is on a bracket connected to the camera. That way, you can be sure that the flash will always

be pointing in the right direction relative to the camera lens.

Flash Bracket—Several flash brackets specially designed for close-up photography are available. The best enable you to raise, lower, swivel and tilt the flash heads in virtually any direction. This means you can aim the light accurately at the subject from almost any angle. You also have complete control of the flash-to-subject distance and can repeat it accurately. By mounting two flashes, one on each side of the camera, you can achieve an endless variety of illumination.

With camera-mounted flash, you move the lights closer to the subject as you bring the camera nearer for greater magnification. Therefore, you automatically get more light on the subject when you need it. This minimizes the need for exposure adjustment.

Modeling Light—Because most small flash units do not have a modeling light, you can't see the precise effect the lighting is going to have.

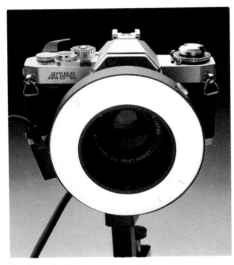

A ring light surrounds the camera lens, giving soft and shadow-free flash illumination. Ring lights are designed to be operated either from a separate power pack or from a 120-volt outlet.

However, you can improvise. Use a small flashlight to find the best location for the light source. Having found it, put the flash head at the same position.

Automatic Flash—Automatic flash is wonderful for general photography at

normal distances. Although it can be used close-up, there are some precautions you must take. When you use your flash in the auto mode, remember these points:

• The electric-eye sensor on the flash does not compensate for the need for increased exposure due to camera extension.

• An electric-eye sensor on the flash unit does not "see" precisely the same thing the camera "sees." This is because of parallax between lens and sensor at close range. This problem can be avoided if you have a flash unit with a separate sensor that can be aimed independently.

• Your flash unit may not work in the auto mode at the small lens aperture you want to use for close-up work. At the aperture settings possible in the auto mode, you may not be able to bring your flash close enough to the subject.

There is, however, a fairly simple way of avoiding the two last mentioned limitations: tape a neutral density (ND) filter over the electric eye sensor of the flash. For example, an ND 0.6 filter reduces the amount of light transmitted by a factor of about 4, or two exposure steps. By using such a filter, you can halve the distance from the flash to the subject and still use the auto mode. Or, you can stop the lens down by two more stops and still remain in the auto mode.

TTL Flash Metering—Most suitable for close-up and macro work is a camera/flash system that provides through-the-lens metering. This system automatically provides the exposure increase needed because of extra camera extension. However, the system may not work at the extremely close flash-to-subject distance or the small lens aperture you want to use.

Slave Unit—You may want to use a slave unit to fire one flash from another without wire connections. At close range, the duration of an automatic flash can be as short as 1/30,000 second. Some slave units may not respond to such an ultra-short flash. Check with a dealer, before buying.

Manual Flash—In many respects the best way to use flash for close-up and macro work is in the manual

mode. Automatic flash—except the through-the-lens kind—does not compensate for the light loss caused by long camera extensions. Also, the other disadvantages mentioned earlier can lead to considerable exposure errors.

When you work in the manual mode, use the guide number recommended by the flash manufacturer to begin calculating exposure. However, here's one important point you must realize: flash reflectors are built for use at normal shooting distances of several feet. At close range, they are usually less efficient.

When using flash close to the subject, use about 2/3 the flash-to-subject distance indicated by the guide number to approximately compensate for this efficiency loss.

Determine the exposure increase factor in the manner described earlier. Then bring the flash even closer to allow for this factor. Divide the distance by the square-root of the factor.

For example, let's assume the factor is 2 and the original flash-to-subject distance 20 inches. The new distance will be 20 inches/1.4 = about 14 inches.

Here's another example: If the factor is 4 and the distance was 24 inches, the new distance will be 24 inches/2 = 12 inches.

▼ This simple setup shows how you can achieve transillumination and top light. Notice the slave unit on the flash at left.

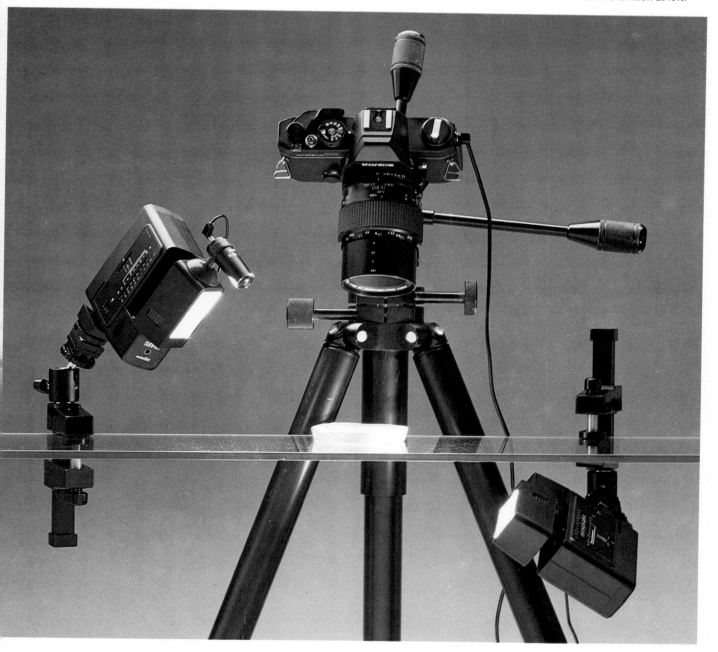

If you find you cannot bring the flash close enough to the subject, stop down the lens more. If the lens is already stopped down fully, use a neutral-density (ND) filter on the flash or the camera lens. Or, place a diffuser over the flash, if that doesn't soften the illumination too much.

To be sure of well-exposed photos, bracket exposures liberally. For future reference, keep a record of all your exposure data and the results you obtain. It will help to speed up your work and make it more economical in future.

Ring Light—This is a special flash unit particularly useful for close-up work. The light source surrounds the camera lens. This source produces almost totally shadowless illumination. It is especially useful for subjects that have deep indentations or cavities. All parts visible to the camera lens are lit equally. There are no deep shadows to hide subject detail.

Special ring lights are available that have four independent flash tubes at top, bottom, left and right. Each of these lights can be switched on and off independently. This allows you to introduce shadows and enhance modeling in the subject.

When you shoot a shiny subject head-on, the ring-light flash will reflect back to the camera lens. This reflection can be reduced or eliminated by the use of a special pair of polarizers over the ring flash. One polarizer goes over the flash and the other over the camera lens. The two polarizers are crossed to each other.

When you can't remove all the reflection, try shooting the subject at an oblique angle.

TUNGSTEN LIGHT

The most obvious advantage of tungsten light over flash is that it gives a continuously burning light. This enables you to see and evaluate the effect of different light positions before you shoot.

However, there are also some disadvantages. To be able to use a reasonably short exposure time and small lens aperture, high light intensity is required. Tungsten lights generate heat. When they are placed close, the heat can damage both the camera and subject.

When shooting color slides, use a film balanced for tungsten illumination. With daylight-balanced color film, corrective filtration is necessary. This calls for an additional exposure increase—and introduces further possibility of blurred or unsharp pictures.

For close-up photography, you can use a household table lamp. For macro work, where greater light intensity is called for, special macro or microscope illuminators are available. They give a concentrated, bright light over a small area. Alternatively, you can use the light from a slide projector to illuminate the subject.

If you're going to do a lot of high-magnification macro work, a fiber-optic light source may be a good investment. It gives bright illumination over a small area. This light source is very flexible. You have freedom of location even when the working distance between lens and subject is very limited.

DAYLIGHT

Diffused daylight can be useful in much close-up photography. However, in the macro range the subject brightness attainable is generally too low for practical purposes. Also, the constantly varying brightness of daylight makes exposure consistency difficult.

LIGHTING TECHNIQUE

A small object can be illuminated from virtually any side. Every time you move the light source, you get a different effect. Following are the basic light positions:

Front Light—The light source is as close to the lens axis as possible. Shadows are small and usually unobtrusive. If the working distance is very short, frontal lighting may be difficult or impossible to achieve.

Side Light—Light reaching the subject is at an angle of about 45° from the lens axis. It causes distinct shadows, helping to bring out texture

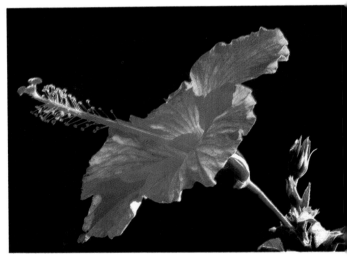

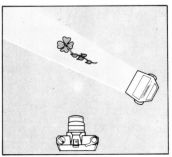

SIDE LIGHT
Aim the light at an angle of about 45° to 60° from the lens axis. This lighting is ideal for emphasizing a subject's shape and texture.

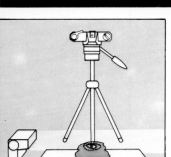

CROSS LIGHT
The light just skims the surface of a flat subject, revealing surface texture. To lighten deep shadows, use a reflector on the side opposite the light.

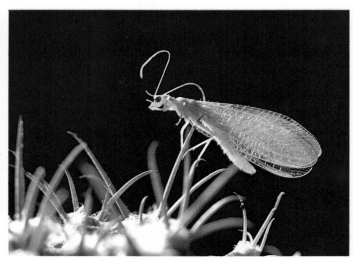

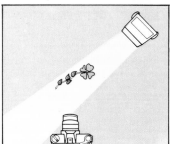

BACK LIGHT I
For bringing out detail in a translucent subject, light it from behind. To retain the detail, use a dark, plain background. If frontal detail is needed, add a light to the front of the subject.

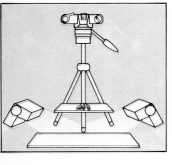

BACK LIGHT II
To bring out the internal structure of a translucent subject, you can place the subject on a light box. Or, place it on a sheet of glass. Raise the glass several inches above a sheet of white paper. Light the white paper evenly. With the same technique you can produce silhouettes of opaque subjects.

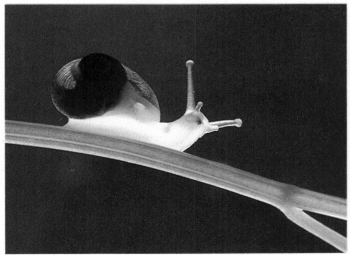

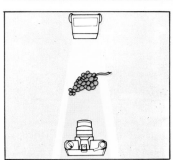

BACK LIGHT III
To penetrate a relatively dense translucent subject, place a small, bright light source immediately behind it. Here, a microscope illuminator was directed at the snail through a hole in the background paper.

in a subject. You can soften the shadows by placing a white reflector card on the shadow side of the subject. Side light is easy to place, even with a short working distance.

Cross Light—This is extreme side light. The illumination just glances off the surface of the subject. Contours and detail in finely textured or engraved subjects are brought out.

Also known as *darkfield illumination,* this technique is useful in lighting coins and medals. It highlights raised contours and outlines against a dark coin base, or field. The best effect is usually achieved with two lights, one on each side of the subject.

Back Light—The light comes from behind the subject. When a solid object is placed on a light box, a silhouette results. When a translucent or transparent object is lit from behind, either with a light box or a

directional light source, detail is brought out in the object.

Often, the best photographic effect is achieved when back light is combined with some frontal illumination.

Rim Light—Its purpose is to illuminate the outer edges or rim of a subject. The rim light usually is aimed at the subject from the side farthest from the camera, the light source remaining outside the picture area. Rim light is usually most effective when the background is dark.

Vertical Illumination—This is *true* front lighting. The light reaches the subject along the lens axis. It is achieved by placing a small, thin piece of optically flat glass between lens and subject. A cover glass for a microscope slide does the job very well.

The glass should be at a 45° angle to the lens axis. The glass is lit horizontally by a concentrated spotlight

source. The light is reflected from the glass down to the subject. From there it returns through the glass to the camera lens and the film. Vertical illumination is totally shadowless.

Also known as *brightfield illumination,* this technique is also popular for illuminating coins and medals. It renders the raised and lowered contour in dark outline against a bright field.

SPECIAL LIGHTING AIDS

In addition to a light source, the following accessories are very helpful to the macro and close-up photographer:

Reflectors—When possible, it is advisable to use only one light source. Additional lighting, to fill shadows or add catchlights to the subject, can be provided with simple reflector cards. For macro work, a small, white card can work wonders.

Mirrors—When positioned correctly,

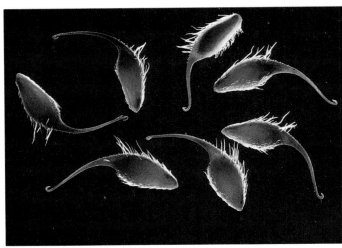

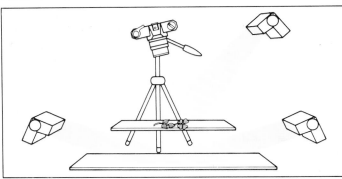

SHADOW-FREE LIGHT
If you want a top-lit subject without shadows, use the setup shown. Place the subject on glass. Raise the glass several inches above a white card. Light the subject from above. Light the white paper separately and uniformly.

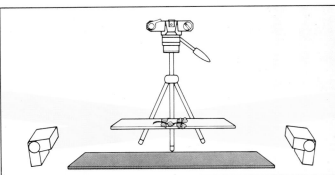

RIM LIGHT
Place the subject on glass. Raise the glass several inches above a black background. Black velvet is best. Illuminate the subject almost horizontally from both sides. The result will be the detailed outline shown in the photo above.

small make-up mirror can almost turn one light source into two.

Light Tent—These are discussed more fully on page 58, in the *Still Life* section of this book. However, a special miniature light tent can be very useful to the macro photographer. With a shiny subject in a tent that is illuminated from the outside, glaring highlights and reflections can be avoided. The tent also prevents the unwanted reflection of surrounding objects.

You can easily make a tent from white paper or some other white, translucent and flexible material. Very small tents can be made by cutting a table-tennis ball or an empty egg shell in half.

Glass Plate—You can raise an object above its background by placing it on a sheet of flat, clean glass. By using side lighting, you can make the shadow of the object fall outside the picture area.

You can also use a glass base when you want to light the object from below. The background can be light or dark, depending on the shade of the

material you use and the brightness of the light on that material.

EXPOSURE CORRECTION

At a given lens focal length and aperture, the farther the image is from the lens the dimmer will be the light reaching the film.

Close-Up Lenses—With these lens attachments, image magnification is achieved without adding to the normal camera extension. Therefore, no exposure compensation is necessary.

Extension Tubes and Bellows— Because an increase in magnification is achieved by increasing the lens-to-film distance, exposure has to be increased accordingly. See details in the *Extension Bellows* section, pages 16 to 20.

You can change the light brightness at the subject by changing the lamp distance. As a rough guide: halving the lamp distance gives four times as much light at the subject. Reducing the lamp-to-subject distance to 2/3 causes a doubling of the light brightness at the subject.

With some lamp types, you can also change illumination brightness at the subject by adjusting the lamp intensity.

Because many variables make it impossible to recommend precise exposure settings in close-up and macro photography, bracket exposures liberally.

CALCULATING *f*-STOP SETTING WITH ADDED EXTENSION

The *f*-number setting of the camera lens relates to the focal length of the lens. When the lens is focused at infinity, the lens-to-film distance is equal to the focal length. Even when the lens is focused at several feet, for normal photography, the lens-to-film distance is not greatly different from the focal length.

However, in the close-up and macro range the lens-to-film distance can be considerably greater than the focal length. For example, at a magnification of 1, that distance is twice the lens focal length.

The added extension makes the *effective aperture* smaller than the real *f*-number set on the lens aperture scale. To determine what *f*-stop to set on the lens to get a specific effective aperture (EA), use this formula:

$$\text{f-stop on lens} = EA/(M + 1)$$

Example: A meter reading has indicated that an aperture of *f*-22 would give correct flash exposure. You are using a lens extension to achieve a magnification of 1.75. Use the formula to determine what aperture to set on the lens to achieve the effective aperture of *f*-22.

$$\text{f-stop on lens} = \textit{f}\text{-22}/(1.75 + 1)$$
$$= \textit{f}\text{-22}/(2.75) = \textit{f}\text{-8}$$

To get correct exposure, you should set the camera lens to *f*-8.

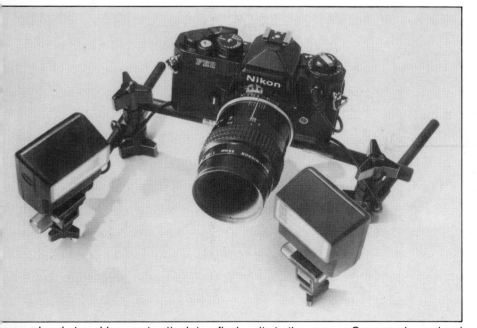

macro bracket enables you to attach two flash units to the camera. Once you have aimed the lights at a subject at a specific distance, you can be sure they will remain that way. As you approach a subject for greater magnification, the lights also come closer. This minimizes the need for exposure compensation. The bracket shown, and other useful close-up/macro equipment, is available from Lepp and Associates, P.O. Box 6224, Los Osos, CA 93402. The flash units attached to the bracket can be swung in or out, and tilted, to achieve the required lighting effect.

Shooting Typical Small Objects

You may want to photograph small objects such as the coins, medals and jewelry shown on these pages for one of several reasons. Perhaps you want a pictorial record for insurance or sales purposes. Delicate jewelry can easily be damaged or lost. If you have valuable stamps, you would not want people to handle them. However, you won't mind handing people photos of valuable items.

Perhaps you want to photograph small objects simply because they are beautiful and you want a record of that beauty. Whatever the reason for your photography, you'll get the most satisfaction from the pictures if they are sharp and well lit.

EQUIPMENT

Coins, medals and stamps are all flat objects. Although jewelry is basically three-dimensional, when photographed it usually also lies in a flat plane. The photos on page 37 show this clearly. You'll want to photograph most of these objects head-on.

You need a sturdy setup for camera and subject that eliminates the possibility of vibration or movement during exposure.

The base on which the subject lies should be flat. The camera lens axis should be perpendicular to that base.

You require at least two lights—one on either side of the subject.

Mount your camera on a sturdy tripod. Aim the camera downward. You can use either a table or the floor as the baseboard. To be sure the camera is pointing in a true vertical direction and the baseboard is horizontal, check each with a level.

Copy Stand—If you plan to copy small objects regularly, a specially made copy stand is a good investment. It is an integral unit of camera stand and baseboard and often includes lights. Be sure to get a unit that's sturdy and properly aligned, as described above.

Lighting—For the versatility you need for copying varied objects, you should have two lights. You may not need them for every shot, but you will for most. The lights should be of similar type and brightness.

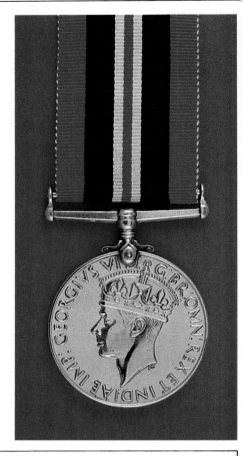

DARKFIELD ILLUMINATION

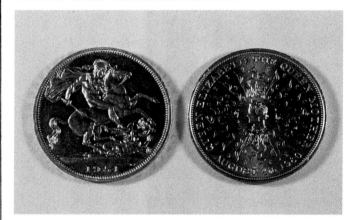

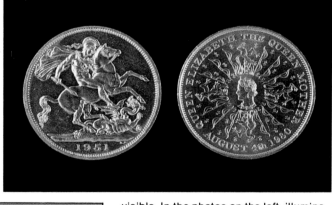

When the lights are lowered toward the plane of the coin or medal, the field will appear dark. The raised contours and outlines will be highlighted. The best light positions depend on the characteristics of each subject. In the pair of photos on the right, illumination is uniform and all the detail in the coins is visible. In the photos on the left, illumination is uneven and much detail is lost. Examine the viewfinder image carefully while you adjust the light positions. The black background in the photos on the right also enhances the image and eliminates unattractive double shadows.

BRIGHTFIELD ILLUMINATION

◄ Ideal brightfield illumination is achieved when the light comes along the lens axis, as described in the text. The surface, or field, of the coin or medal records as a bright surface. The contours and outlines are dark. The result resembles an ink drawing on white paper.

Photos of coins don't all have to be straight record shots. Here, careful composition and selective focus led to a creative photograph. The coins were raised to different levels with supports invisible to the camera. The top coin was four inches higher than the lowest. In this case, the limited depth of field characteristic of close-up photography actually helped. The various degrees of sharpness give the photo a three-dimensional appearance.

ALTERNATIVE BRIGHTFIELD ILLUMINATION

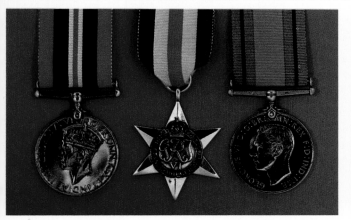

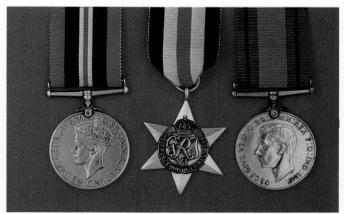

Brightfield illumination along the lens axis won't work when you have three medals close to the camera lens, as shown here. That's because the coins at the side will not be lit frontally. There's a good compromise lighting method for such cases. Construct a *tent* of white, translucent material around and above the medals, as shown in the drawing.

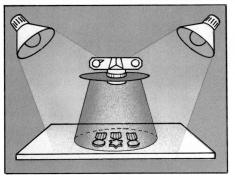

Light the tent evenly from the outside. The result will be good, photo on the right, although perhaps not as even and detailed as that produced by frontal illumination. This method will save you a lot of frustration and avoid unsatisfactory results, like the one shown in the left photo. For more details about tent lighting, see pages 58 to 61.

For *hard* lighting, giving distinct shadows and highlights, use small spots such as micro illuminators. For *softer* illumination, you can use a couple of table lamps. Or, you can use indirect illumination by reflecting light from a couple of reflector cards.

Modeling Light—There's no such thing as a standard lighting setup for photographing coins, medals or jewelry. Every object calls for its own illumination. And, the lighting you use depends on how you want to depict the object. Therefore, it's important that you *see* the effect of the light before you shoot. With tungsten light, this is easy. With flash, you don't see the effect of the lighting until the film is processed.

To help you place your flash, use improvised modeling lights, as described on page 28. When you're happy with the position and quality of the light, carefully replace your modeling lights with the flash units. Try to also duplicate the softness or hardness of the lighting effect.

COINS AND MEDALS

Although coins and medals are flat objects, they differ in important ways from normal flat copy. They are metallic and shiny, and the detail on them is not flat but contoured. The image is made up of raised and lowered parts, somewhat like a very flat sculpture. You can record the detail on a coin or medal in one of two ways.

Dark Field—You can render the contour lines brightly against a dark background. This is called *darkfield illumination*. It is achieved with side lighting, as shown in the diagram on page 34. Often, the lights will need to be placed lower than shown. To achieve the best effect, study the image in the viewfinder carefully as you adjust the lights.

Bright Field—If a coin or medal is lit from directly above, the field will be recorded brightly. The contoured lines will appear dark. How to achieve this *brightfield illumination* is described on page 32.

Heads and Tails in One Photo—Sometimes you may want the front and reverse side of a coin or medal in one photo. You can achieve this, even if you have only one coin or medal.

With b&w or color-negative film, shoot the two sides of the specimen on two different frames. Limit one image to the left half of the frame and the other to the right half. Use a deep black background—black velvet works best. It's important that no light is reflected from the background.

When the film has been processed, sandwich the two negatives together so the images are next to each other and both right-reading. Stop the enlarger lens down sufficiently to ensure sharpness of both images. You can then make one enlargement of both sides of the coin or medal.

If your camera has a double-exposure facility, you can use a double-exposure mask on your camera. Mask one side of the film while exposing the other. Reverse the coin, move the mask to the other side of the frame and expose again. You'll have both images on one piece of film. A double exposure mask is made by Cokin. It's not difficult to make a similar device yourself.

You can also make a double exposure by using black velvet, mentioned earlier, as background. Be sure no light reflects back to the camera from the velvet. Locate the coin so its image occupies one side of the viewfinder frame. Make the exposure. Turn the coin over and locate it on the other side of the frame. Expose again.

JEWELRY

Most jewelry is bright and is, therefore, best photographed on a dark background. Deep red is suitable in many cases. So is dark gray or black. The exact background you choose depends on the color of the jewelry and on your own taste.

The jewelry depicted on page 37 was illuminated through a light tent. This provided soft, attractive illumination. If you want to reproduce some parts of the subject darker than others, simply place black strips of paper inside the tent at the appropriate points.

If you want to add a bright catchlig to part of the subject, cut a hole in tent and direct a small spot light at th desired point. Take care that the sp light is not too bright in relationsh to the general illumination comir through the tent.

Study the lighting effect carefully the viewfinder. Adjust the lights necessary, until you have the preci effect you want.

For more details on light tents, s pages 58 to 61.

STAMPS AND FLAT COPY

Coins and medals generally occu the central part of the image are only. Jewelry is irregular in shape ar also rarely extends toward the corne of the image frame. Stamps and oth flat copy are different. They are di tinctly rectangular, usually occu most of the picture area and hav minute detail of lettering or desig over their entire area.

Getting good images of posta stamps calls for a lens that gives a image that's sharp from corner corner. The image must also t undistorted. This means a rectangul stamp must not record to look barre shaped or like a pin-cushion. Final the image must be illuminated equal over its entire area.

You need a flat-field, distortion-fr lens. Ideally, use a macro lens or a enlarger lens. If you use a regula camera lens, reverse it in the came for best performance. For be results, especially at hig magnifications, avoid wide-ang lenses, zoom lenses and close-up-le attachments.

CLEANLINESS

Remember that dust, dirt and blem ishes are magnified along with th remainder of the image. In close-u and macro photography, thoroug cleanliness is essential. Clean all ob jects carefully before photographir them. Just before you make a exposure, check to be sure no du has settled within the image area.

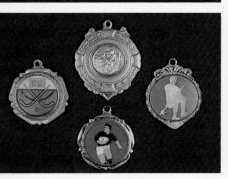

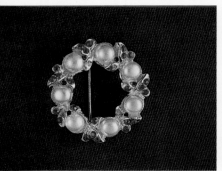

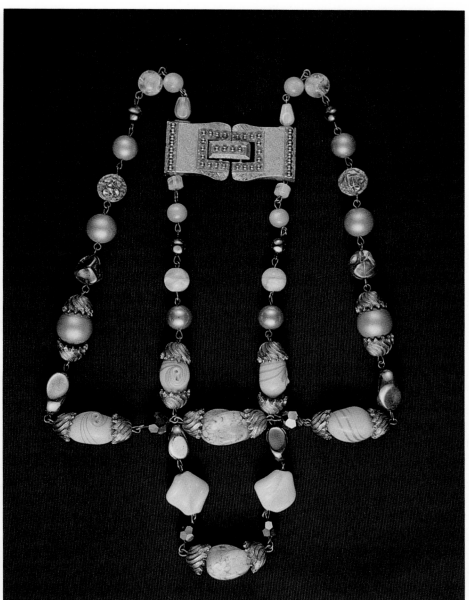

Each of these jewelry photographs was made in the same way. The photographer constructed a small light tent with white paper. He illuminated the tent from the outside with two lights. A small hole on each side of the tent made it possible to adjust the jewelry within the tent. The uniform dark background directs a viewer's attention to the jewelry. This simple setup is ideal for photographing many items, such as for insurance purposes.

STILL-LIFE
PHOTOGRAPHY

Composition

Macro and close-up photography usually involve the production of relatively large images of small objects. The purpose is to record as much subject detail as possible. There's generally little need or opportunity for creative image composition.

Still-life photography is different. It involves not simply the photography of one object but the effective combination of objects to produce a pleasing picture. A still life need not be in the category of close-up photography although often it is. Sometimes it even involves macro photography.

Whatever the size of the resultant image, still-life photography involves image *composition*. Composition ensures the pleasing interrelationship of components within the one image. It is affected by several considerations.

The still-life photographer has a great advantage over the photographer of living subjects. Because his "subjects" don't move, he has total control of subject placement, angle of view and lighting. He can study a visual effect and, if he doesn't like it, he can change it. He can even process the film and come back to find the setup and tripod-mounted camera just as he left them.

SUBJECT PLACEMENT

The most obvious aspect of composition is the placement of the subject components to produce a pleasing picture. It helps to follow certain guidelines.

Rule of Thirds—The Rule of Thirds indicates the visually most effective and pleasing position within the frame of major subject components. It is generally—but not always—about a third of the way into the picture, both

Composition plays an important part in still-life photography. You're constructing a close-up "scene" and the individual components must be arranged in a pleasing way. Another important consideration is cleanliness. Remember that, as you enlarge an image, dirt and blemishes are also magnified. Select objects that are not damaged or scratched. Clean each object carefully before photography.

orizontally and vertically. The posi-
on of the tomato in the picture on
age 45 is a good example.

alance—The image should not be
op-heavy or lopsided. Avoid placing
l the large objects on one side of the
ame and the small ones on the
ther. Imagine that large objects are
eavy and small ones are light. When
ou have made the composition, the
'weight'' should be distributed fairly
venly in the image area.

Dark objects also tend to appear
eavier than light ones, so don't lump
l dark objects together.

OLOR COMBINATIONS
Maintain harmony in your colors.

A high, diffused main light produced the modeling and soft shadows in the photo below. The lighting was softened further with reflectors on both sides. To build the composition, the photographer placed the basket and vase first. He then carefully adjusted the flowers and leaves. Then the small objects were added. The photographer examined each adjustment through the viewfinder. A baffle was added to the setup to darken the upper background.

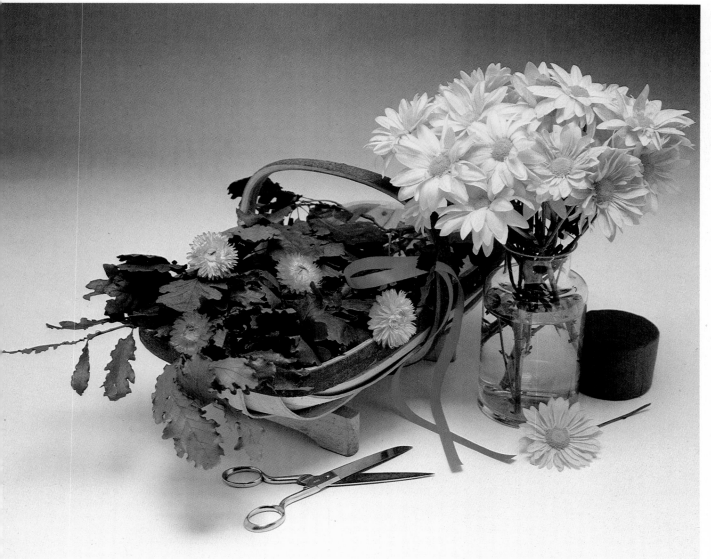

Don't mix too many colors in one image. Don't combine colors that clash, unless you want a specific effect. For example, red and purple seldom form a pleasing combination.

Color harmony and color contrast are subjects too complex to deal with in detail in this book. The best practical guide is to use combinations that please you and avoid those that don't. In the long run, the appreciation of your compositions will also largely depend on the taste of the viewer.

Don't be afraid to use neutral backgrounds—black or gray. They can often be very effective because they keep the viewer's attention on the subject matter.

VIEWPOINT

Carefully choose the best angle, considering subject placement and picture balance, as described earlier. Also, choose an angle that best conveys the information about the subject you want to record.

Decide whether you want to look down at the subject from above or use a low viewpoint.

PERSPECTIVE

If you want to convey the impression that the viewer is very close to the subject, bring the camera close. To get the whole image into the frame, use a wide-angle lens. If you're working in the macro range, set your camera for an appropriate magnification. Use a lens with a short working distance.

You may want to minimize the size difference between objects that are near to and far from the lens. You do this by moving the camera away as far as possible. To fill the frame, you may need a telephoto lens. In the macro range, use a lens with a long working distance.

SELECTIVE FOCUS

Focus also has a decisive effect on composition, as you can see from the pictures at the top of page 44. When the background is sharp, it becomes

COMPOSITION

▶ Pictorial composition involves the arrangement of the components of a scene. Object sizes, shapes, locations, colors and tones should combine in a harmonious way. What makes a good composition is largely a subjective evaluation. In the four photos on the next page, the photographer experimented until he achieved the effect he found most pleasing.

Top left: The objects were put down arbitrarily, with no thought given to a pleasing composition.

Top center: The white envelope, which had dominated the scene, was placed to the side and partially covered with the picture frame. The picture was angled to give a more casual and three-dimensional effect. The wooden egg was moved to the left side to complement the curve of the jug's handle. The fern was trimmed back on the left side.

Top right: The fern was replaced by flowers to introduce more color. However, the red vase was too colorful and large. It seemed to overpower the scene.

Bottom: The flowers were placed in the brown jug. The remainder of the arrangement was unchanged. The photographer found this to be the best composition. What do you think?

ANGLE OF VIEW
These are the flowers used in the still life on the previous page. The purpose of these two photos is to show the difference viewpoint can make. The horizontal view reveals the stems and their arrangement in the vase. The high view emphasizes the blooms and almost hides the vase. The yellow blooms also appear brighter against the medium-gray background.

 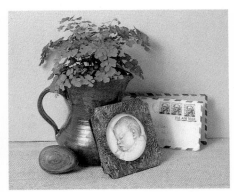 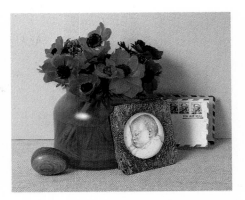

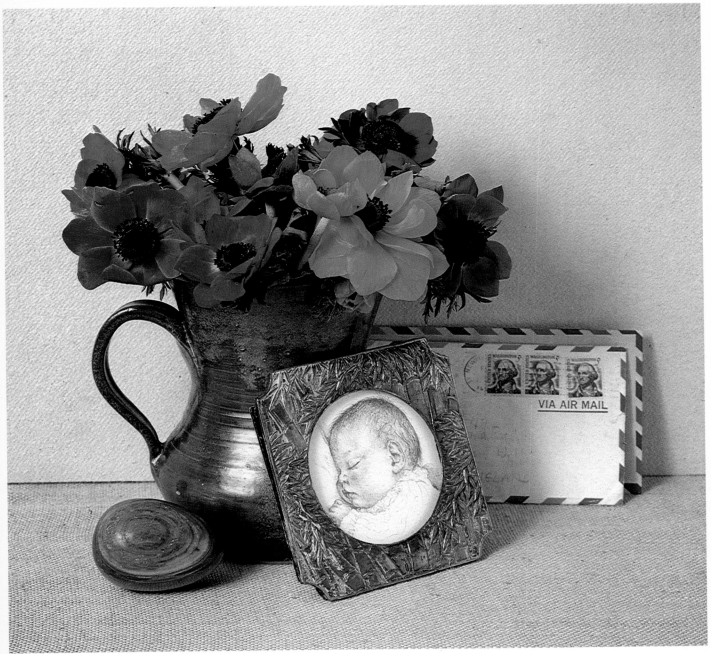

DEPTH OF FIELD
Left: The aperture used was *f*-22. Depth of field was sufficient to render the box behind the toy in reasonably sharp detail. The picture of the boy on the box helps tell a story. However, the outline of the toy is difficult to distinguish.
Right: An aperture of *f*-5.6 was used. Because of limited depth of field, the background became an abstract blur. Although the background colors are similar to those of the toy, the sharply defined toy now stands out clearly from the background.

part of the image and must be considered part of the total composition. When you put the background totally out of focus, it becomes a vague patch of tones and colors and has no real effect on the composition.

By using your camera's depth-of-field preview button, you can adjust the lens aperture until you have exactly the focus effect you want. If your camera doesn't have a preview button, use the depth-of-field scale on the lens body.

LIGHTING

The proper use of light, shade and contrast also has a decisive effect on image composition. For example, by changing from contrasty to shadowless light, or by changing the direction of shadows, you can alter the whole pictorial effect. Lighting the still life is discussed in the next two sections.

▶ In still-life photography, lighting can have a decisive effect on composition. Lit differently, this scene could have achieved a totally different effect. Notice the obvious care with which the illumination was built up, one light at a time. Observe the texture of the bread, the highlight on the crust, and the rim light on the onion. The tomato was given its translucent appearance by a strong, hidden back light.

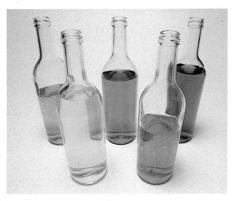 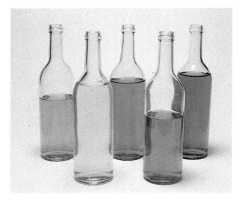 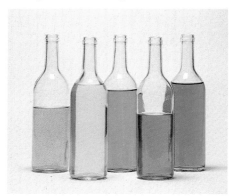

DISTANCE AND LENS
Shooting distance affects the appearance of an image. At the chosen shooting distance, use a lens that will fill the film frame. Left: Close viewpoint and 28mm lens. The camera was pointing down. Hence the different height of the bottles and the converging vertical lines. Notice also the apparent size difference between the bottles. Center: More distant viewpoint and 50mm lens. The camera was a little higher than the bottle tops, as you can see from their apparent different heights. The bottle sides now appear almost parallel. Right: Still farther away, with 105mm lens. The distance between the bottles was not changed, yet they all appear nearly the same size. Their sides appear parallel.

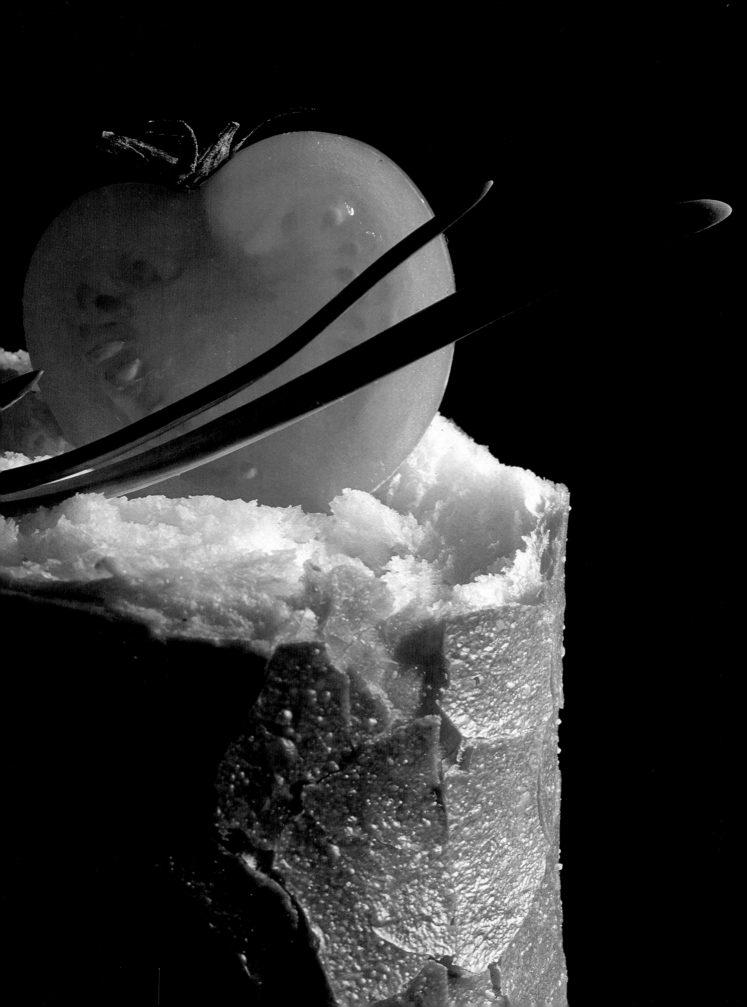

Basic Lighting

In this section you'll learn how easy it is to produce good still-life photographs with a simple lighting setup. All photos in this section, with the exception of the one on page 51, were made with one light source. The lighting used for each picture was electronic flash. However, the same basic principles also apply with tungsten lighting.

SIMULATE DAYLIGHT

We are used to seeing the world around us lit from above. To give objects a realistic appearance, be sure your artificial-light source is pointing down at your still-life setup. When lit from below, most objects and scenes take on a strange, unfamiliar appearance. A typical example is a face lit from below. A flashlight pointed up at a face from chest level can produce a grotesque appearance.

In the outdoor world around us we are also used to one main light source—the sun. With one light source, objects cast shadows in just one direction. To make scenes lit by artificial light appear "realistic," it is customary to use only one main light in a studio setup.

MAIN LIGHT

The one light that provides the modeling on a subject and causes the decisive shadow is called the *main light*. Other lights or reflectors should serve secondary purposes. They can include the brightening of shadows, lighting a background and illuminating an object's rim.

For best control of your lighting setup, start out with the studio or room dimly lit. Begin by introducing the main light source. Move it about until the subject has an appearance that appeals to you. Only then should you add other lights.

ADDITIONAL ILLUMINATION

When the main light is properly located, add a *fill light* or a reflector to brighten shadows. The fill light should be diffused and weak enough not to create shadows of its own. Normally, the fill light is near the camera position. Add a *rim light,* if it appears appropriate. Direct another light toward the background, if you want it to appear brighter.

Reflectors are discussed a little more fully in the next section. Some other simple accessories can also help you widen the scope of your basic lighting setup.

Black cards can have the opposite effect of reflectors. You can use them to prevent light from reaching specific subject areas. For example, to achieve the black outline to the glass in the left picture on page 48, the photographer placed a black card on each side of the glass.

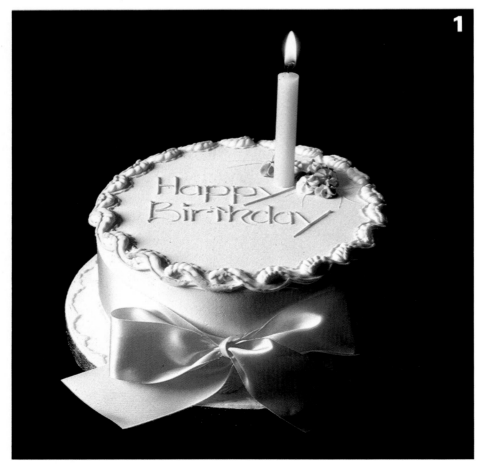

The dramatic lighting in photo 1 was achieved with a simple setup. The cake was placed on black velvet that was curved up to also form the background. One diffused light, placed low and to the left of the cake clearly brought out the lettering. It also gave a solid appearance to the candle. The light source extended sufficiently far to the front to illuminate the pink bow. The photographer switched off all room lights. He waited until the candle's flame was steady. He then exposed the cake with flash and extended the exposure time to one second to record the candle's flame.

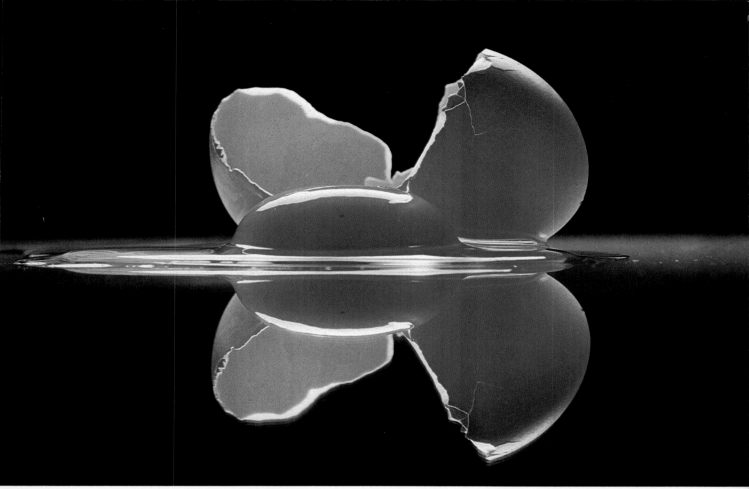

▲ One light source was used. It was low and behind the egg. It did three things: it put rim light on the egg shell, highlighted the egg yolk and gave the shell a translucent appearance. The camera lens was carefully shielded from the light source. The black background extended up to the light source.

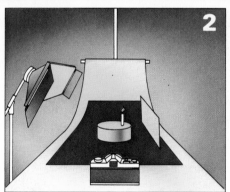

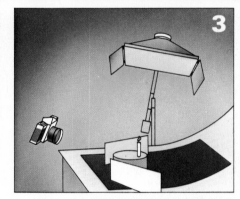

For photos 2 and 3, the light source was raised and reflectors were added. This reduced the detail in the lettering. It also brightened the shadows, taking away the dramatic effect of a candle-lit cake. These examples show you that *more* light doesn't necessarily mean *better* lighting. Photo 1 is the most effective. The lesson: Don't be afraid to *take away* lights or reflectors if they don't improve the image.

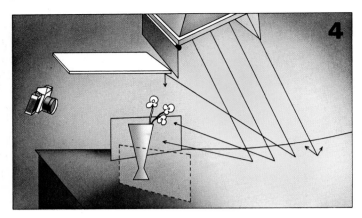

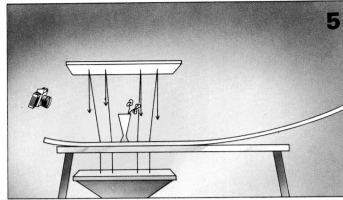

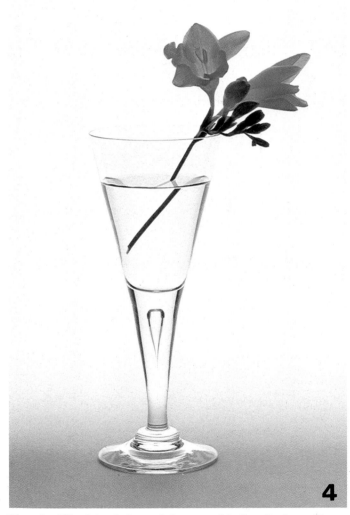

4

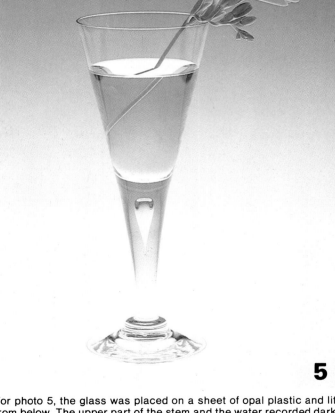

5

Glass is difficult to photograph because it both reflects and transmits light. For photo 4, diffused light was reflected from the white background. However, the glass was so thin that its sides were barely visible. A black card was placed to the left and right of the glass. These cards reflected black into the glass sides. A reflector was placed above the glass to retain some detail in the flower.

For photo 5, the glass was placed on a sheet of opal plastic and lit from below. The upper part of the stem and the water recorded dark enough to give the glass a clearly discernible outline. A reflector above the glass provided the highlight on the water surface and detail in the flower.

Diffusers can soften a light source to give gentler tonal gradation and softer shadows to a scene. By placing a translucent screen between a small light source and the subject, the source automatically becomes larger and the light softer. A diffuser can be made from a simple sheet of tracing paper. Don't place a diffuser too close to a tungsten lamp. The heat from the lamp could ignite the material.

Small make-up mirrors are also useful accessories for the still-life photographer. They can be used to add specular highlights to subject areas. When placed in the right location relative to the main light source, a mirror can almost take the place of a second light source.

WINDOW LIGHT

Window light can provide excellent illumination for a still life. Avoid direct sunlight coming through the window, however, because it is usually too contrasty. Diffused skylight provides good modeling. The shadows

◄ Using a low light that barely glances over the surface of a flat subject, photo 6, brings out detail. Notice the texture in the background and the clearly outlined features of the face. The darkening of the background on the left could have been lessened, and the shadows lightened, with a reflector on the left side. In photo 7, frontal illumination has obscured almost all detail in the face. The lack of shadows has taken away the apparent thickness of the figure. Side lighting was clearly best for this particular subject.

▼ For photo 8, a spotlight was aimed at the teapot from the right at a vertical angle of about 45°. To soften the harsh highlight, dulling spray was applied to the pot. For photo 9, a large, diffused light source was used. It eliminated the unattractive shadow. Also, the modeling in the pot was more gentle and appropriate to the piece.

can be brightened with the use of reflector cards.

The main disadvantage of window light is its inconsistency. It varies in brightness as well as color at various times of the day and with different weather conditions. With flash and tungsten light it is much easier to achieve correct exposure and good color balance consistently.

BACKGROUND

The background can often be regarded as part of the lighting setup. The brightness of the background material, together with the amount of light directed onto it, determines the tonality of the background in the picture. The background color also has a decisive effect on the final image.

Translucent plastic sheets and trans-parent glass are useful as a background as well as a base for some subjects. Such materials can be lit from behind.

You can avoid shadows on a base by placing the subject on glass. Or, you can partially illuminate the subject from below, through the base. This was done with the right photograph on page 48.

Black backgrounds are often suitable for still-life subjects. To get a really deep black, nothing is better than black velvet. It absorbs almost all the light striking it.

STURDY SETUP

Still-life photography usually calls for small lens apertures for maximum depth of field. Long exposure times with tungsten light or daylight should not present a problem because the subject is stationary. However, the setup must be sturdy. The table on which the still life is arranged must be solid. Put the camera on a tripod that is truly secure.

Avoid work areas that may be prone to vibration caused by machinery, passing traffic or people walking by.

The picture below shows the setup for the photo on the opposite page. Two lights were used. One diffuse source was placed above and slightly behind the glass. The other light transilluminated the background. To provide additional sparkle, two small mirrors reflected the top light toward the glass. A narrow strip of aluminum foil behind the stem of the glass produced a highlight.

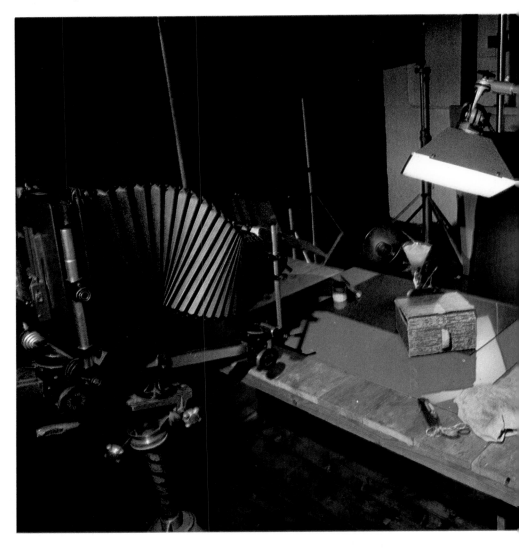

Reflectors

As indicated in the previous section, reflectors can play an important part in your lighting. The type of reflector on a lamp has a significant effect on the quality of the illumination. Separate reflectors can take the place of secondary light sources. This can cut your equipment cost, make your lighting equipment more compact and portable and often simplify your setup.

REFLECTOR TYPES

There are many types of reflectors, each intended to achieve a specific effect.

Lamp Reflector—This reflector type is attached to the light source. To produce contrasty lighting that leads to deep and well defined shadows, the reflector should be relatively small.

A pan reflector, which is relatively large, will give accordingly softer illumination at the same lamp-to-subject distance. An umbrella reflector, anywhere from three to six feet in diameter, gives very soft, almost shadowless, lighting.

The larger the reflector, the softer the illumination from a specific lamp-to-subject distance. In close-up work, the light source will generally be closer to the subject than it would be, for example, for portraiture. Thus, a relatively small reflector will give a moderately soft light.

Separate Reflector—Reflectors that are not an integral part of the lighting unit generally come in the form of cards. Such reflectors can be purchased or easily made from white cardboard. Their function is to pick up light from the main source and direct it back toward the subject. The purpose is generally to brighten shadows. However, there are also other uses.

For example, the main source could be placed behind the subject to yield a rim light. A reflector in front of the subject would then play the part of main light. It would redirect the main light onto the subject from the front.

Natural Reflector—Many objects in your normal environment act as effective reflectors. White walls and ceilings are good examples. In close-up work their usefulness is somewhat limited. Nonetheless, you can often make good use of a wall near the setup to redirect light onto the subject.

Reflector Color—When you're taking color photographs, there's one thing your reflector *must* be if you want correct color balance: it must be white or colorless. For example, a pink or green card reflector will cause an according color imbalance in the image. A specular reflector, too, must be neutral. For example, a golden fo[il] reflector will impart a distinctl[y] yellowish, warm hue to the image.

REFLECTOR SURFACES—Th[e] quality of the light redirected by [a] reflector is also dependent on th[e] reflector's surface.

Diffused Light—A matte surface wi[ll] produce diffuse, soft illuminatio[n.] Shadows will be minimal or absen[t.] Typical diffuse surfaces are those [of] matte white cards or white umbrellas.

Directional Light—A glossy surfac[e] will give directional, hard ligh[t,] producing decisive shadows. Th[is] kind of light comes from a smoot[h,] shiny metal surface. You can easi[ly] make such a reflector by attachin[g] smooth aluminum foil to a stiff board[.]

A reflector of this type is ver[y] efficient. Only a small proportion [of] the light striking it is absorbed [or] scattered. This kind of reflector [is] ideal for producing frontal main i[l-]lumination from a lamp that's behin[d] the subject.

You can also make a *semi-direction[al]* reflector by crumpling a piece of al[u-]minum foil and then partially straigh[t-]ening it again. The resultant reflecte[d] light will not be specular—as from [a] mirror—but will be more direction[al] than the light from a matte card.

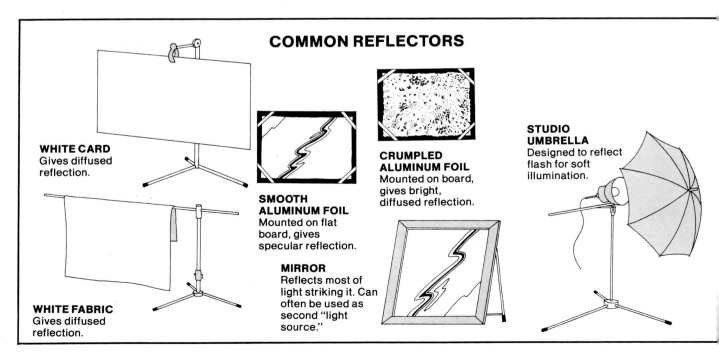

COMMON REFLECTORS

WHITE CARD
Gives diffused reflection.

WHITE FABRIC
Gives diffused reflection.

SMOOTH ALUMINUM FOIL
Mounted on flat board, gives specular reflection.

MIRROR
Reflects most of light striking it. Can often be used as second "light source."

CRUMPLED ALUMINUM FOIL
Mounted on board, gives bright, diffused reflection.

STUDIO UMBRELLA
Designed to reflect flash for soft illumination.

The only light source was above and slightly behind the subject. A large reflector umbrella near the camera softened the overall illumination and added detail to the frontal shadows.

CLOSE-UP LIGHTING

Remember, the softness of light reaching the subject is largely determined by the size of the reflector in relationship to the reflector-to-subject distance.

As stated earlier, in close-up work, the lights will generally be relatively close to the subject. Therefore, you'll get relatively soft light from small reflectors. As a result, most of the reflecting surfaces you'll need for close-up still-life work will be relatively small.

For directional light, to produce distinct highlights and shadows, use small light sources.

The photos on page 54 show you convincingly what can be achieved with a couple of small mirrors and a few pieces of well-placed foil.

It's no exaggeration to say that with one light source, a card reflector, a foil reflector, a couple of make-up mirrors and some aluminum foil, you can achieve nearly any still-life lighting effect you want.

MODELING LIGHTS

If you're using flash, modeling lights are invaluable. However, most small flash units do not have these built into them. To be able to evaluate the effect of reflectors, use improvised modeling lights. Place a flashlight where the flash will be placed. Then position the reflectors to achieve the effect you want. Finally, put the flash back into position.

The proportion of the flash illumination redirected by the reflectors will be very similar to that redirected from the flashlight. To be sure of the exact effect you want, you can "bracket" the reflected part of the light. Make several exposures, leaving the flash where it is but moving the reflectors back and forth slightly.

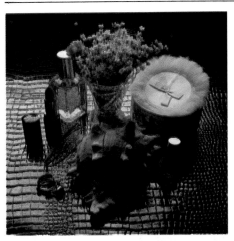

For the left photo, the main light was high and to the rear of the subject. The lighting wasn't *wrong,* but it wasn't *enough.* As shown in the right photo, a mirror was added on the left and a foil reflector on the right. The well-illuminated image below resulted. A small piece of foil behind each bottle added sparkle.

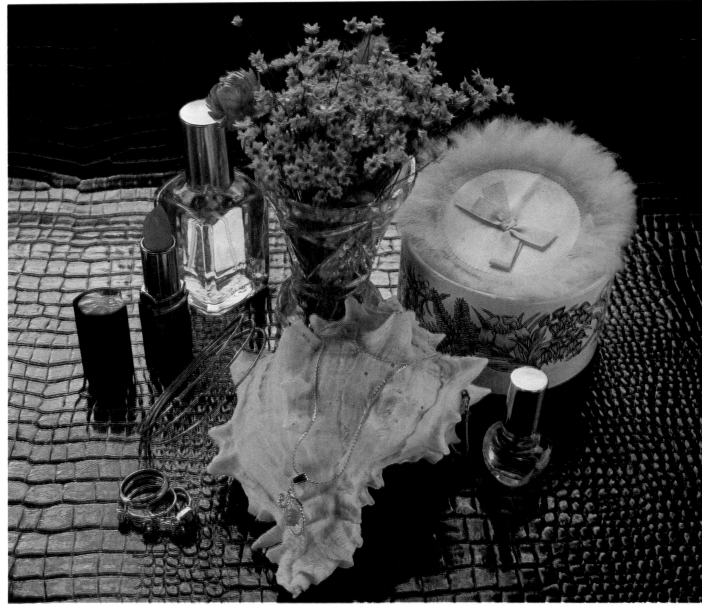

The main light was reflected from a large
umbrella near the camera position. The re-
flected light highlighted the fish and pro-
duced the catchlights in the other items.

Exposure Metering

We've already mentioned exposure in various places throughout the book. But, with a couple of exceptions, no mention has been made of exposure meters.

Meters that make a reading through the SLR camera's lens and camera/flash combinations that enable flash exposure to be read at the film plane are ideal for close-up and macro work. They read exactly what the camera lens sees and automatically allow for lens extensions and special lighting characteristics.

Separate meters, not built into the camera, are much less practical for macro and close-up photography. Much of the problem stems from the fact that there's generally little room between lens and subject for meter placement.

Sometimes it's difficult to place a meter without obstructing some of the lighting. When the subject is very small, a standard-angle exposure meter will read more of the background than the subject. This tends to lead to erroneous readings.

In still-life photography the story is a little different. Often the magnification is low and, therefore, there's ample room for meter placement.

Exposure-Increase Factor—The meters described below do not automatically allow for any needed exposure increase factor. However, much still-life photography will be at magnifications not much higher than 1/10. At such magnifications, the exposure increase factor is very low. Bracketing exposures up to one step (in half-step increments) in both directions should assure you of a well-exposed photograph.

FLASH

To make flash-exposure readings, you need a flash meter. Flash meters are incident-light meters. This means they read the light falling on the subject rather than the light reflected from the subject.

Set the meter for the film speed you're using. Hold the meter close to the subject and point it toward the camera. Be sure not to obstruct any of the lights. Fire the flash—without

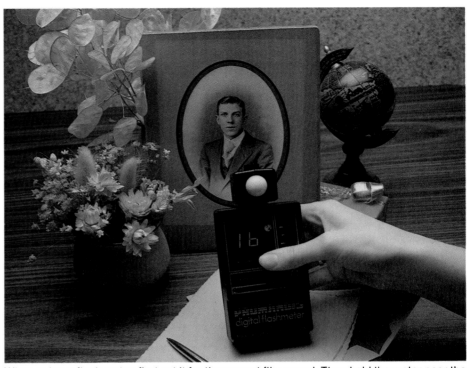

When using a flash meter, first set it for the correct film speed. Then hold the meter near the subject, pointing the incident-light hemisphere toward the camera. Fire the flash with the test button—don't expose film. The meter readout or scale will recommend a lens aperture for correct exposure at normal shooting distances. For close-up and macro work, this aperture must be corrected for added lens extension—see page 20.

exposing film. The meter will indicate the lens aperture on which you should base your bracketed exposures.

CONTINUOUS LIGHT SOURCES

If you use a continuous light source, such as tungsten illumination or daylight, you can use a standard *reflected-light* or *incident-light* meter. A narrow-angle reflected-light meter, called a *spot meter,* is also useful.

Incident-Light Meter—It's used in basically the same way as a flash meter. You hold the meter near the subject and point its incident-light hemisphere toward the camera lens. The meter will indicate correct exposure in terms of shutter-speed and lens-aperture combinations.

Because the meter doesn't "see" the subject, but only the illumination, you must allow for subjects that are darker or lighter than average. For example, if the still life consists mainly of dark components, give a

half or one step extra exposure.

Reflected-Light Meter—This meter reads the light reflected from the subject. It gives an exposure indication in terms of shutter-speed and lens-aperture combinations.

If the still-life contains strong back lighting, that light may reach the meter and cause an inaccurate reading. This would lead to underexposure. To avoid this, take the meter reading from a neutral gray card, placed near the subject plane. A neutral gray card reflects about 18% of the light that strikes it. This represents the light reflected from an average subject or scene. Gray cards are made by Eastman Kodak and available from photo dealers.

Spot Meter—This is also a reflected light meter but reads a very narrow angle of view. It's useful not only for making readings from selected subject areas but also for assessing the contrast—or tonal range—of a scene.

METERS DON'T THINK

It's helpful to think of *light* meters rather than *exposure* meters. A meter reads the light—either incident to the subject or reflected by it. The meter then indicates an exposure. But that exposure is based on the assumption that the subject is average, reflecting about 18% of the light reaching it. It is also based on the assumption that you want to record the subject "accurately" rather than creatively lightening or darkening it for special effect.

To translate the meter's reading into a useful exposure indication, you must evaluate the subject and decide how you want to record it. In other words, you must take the *light* reading provided by the meter and translate it into an *exposure*.

The Gossen Luna-Pro meter is a versatile instrument. You can use it to make incident-light and reflected-light readings. Several of its attachments are useful in close-up photography. Among them is a flash attachment, a spot attachment and a probe that can take light readings from a camera's ground glass. There's even an attachment for taking readings through a microscope.

Making & Using a Light Tent

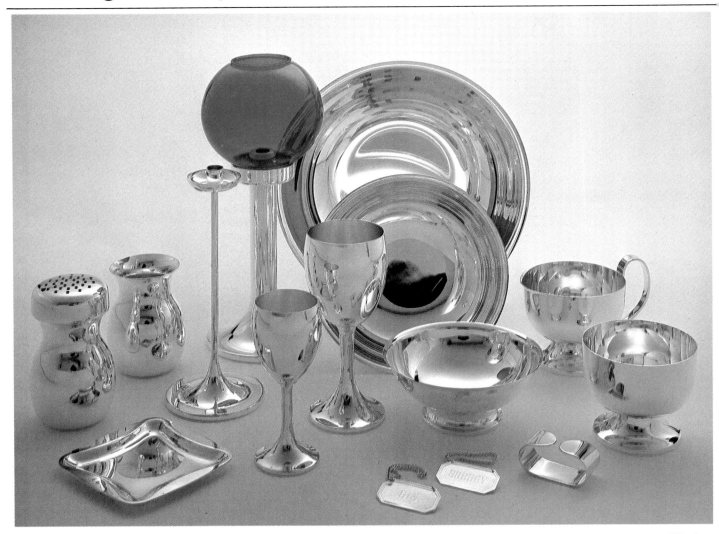

Shiny objects reflect both the illumination striking them and the objects around them. This makes silverware and similar subjects difficult to light and photograph. A light tent solves many of the problems. It produces a uniform, soft light and shields the subject from surrounding objects. Tent illumination yielded the soft, attractive image of this silverware.

Still-life photography is often of such subjects as tableware and ornamental objects. The subject often has bright, shiny surfaces. Bright surfaces reflect everything—lights, dark areas and other objects. These reflections are often unflattering to the object and make for a poor picture.

To avoid reflections, or at least control them, special lighting methods are called for. The classic device for lighting shiny objects is the *light tent*.

Essentially, a light tent is an enclosure made from translucent material. The subject to be photographed is placed in the tent. The camera lens "looks" into the tent through a small hole in the tent material. The tent is lit evenly from the outside. The result is uniform, diffused light and the exclusion of all reflections caused by objects outside the tent.

If you want totally uniform, shadowless lighting, illuminate the entire tent surface evenly. However, often you'll achieve the best effect by adding some shadows, catchlights or dark areas to the still life.

By lighting the tent from one side only, you get some modeling and shadows but still retain the overall soft lighting effect. By taping pieces of black paper at appropriate places inside the tent, you can selectively produce dark reflections in objects to improve the pictorial effect. You can also add small catchlights by cutting hole in the tent and directing a smal spotlight through the hole.

The lighting equipment needed fo tent illumination is minima Generally, two lights are sufficient The lamp reflectors should spread th light over a wide enough angle to illu minate the tent surface evenly.

Modeling Lights—With flash yo should, ideally, have modeling lights They show the exact effect of differen lamp positions. If your flash unit don't have modeling lights, use couple of tungsten lamps a substitutes. Place them so you get th lighting effect you want. Then, pu the flash units in the same position.

58

MAKING A LIGHT TENT

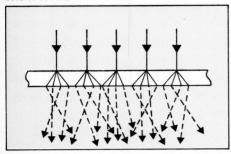

Tracing paper and similar translucent materials diffuse light passing through them.

1) Cut lightweight wood into 20 strips of equal length. The strips should be about 1/2 inch thick and 24 to 36 inches long.

2) Glue the ends of two strips together to form a right-angled corner. Repeat the process to form a square frame. Make five such frames.

3) Strengthen each corner with a small nail.

4) When the glue is dry, staple or glue a sheet of tracing paper to each frame. Before attaching the paper, be sure it is flat and smooth.

5) Cut away surplus paper around each frame. You now have the four sides and top for the tent.

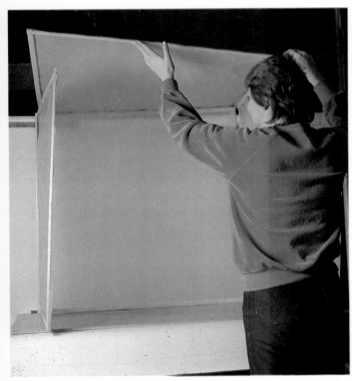

6) Assemble the tent by placing three frames against each other and then adding the top frame. Don't close the front yet.

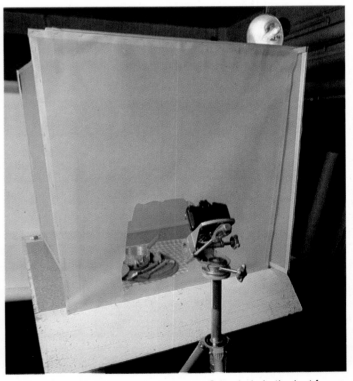

7) Set up the still life and your camera. Cut a hole in the last frame for the camera lens to see through. Add the frame to the tent. Illuminate the tent from the outside.

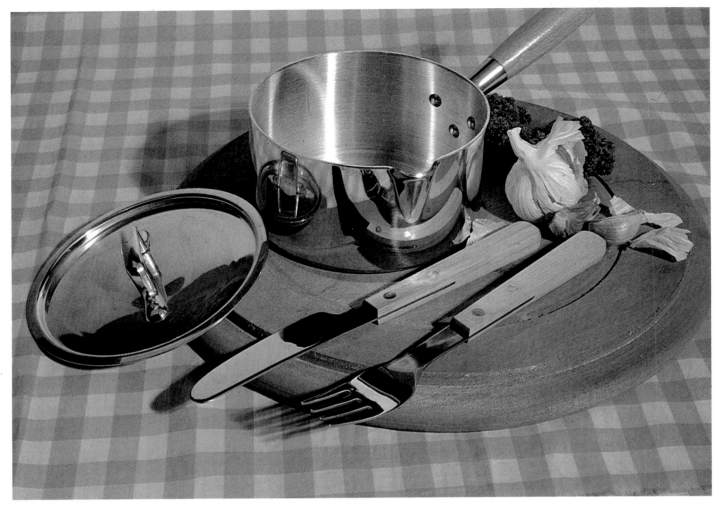

WITHOUT LIGHT TENT
This still life was lit with one light, high and to the right of the camera. There's an undesirable harsh highlight in the saucepan. The dark and light reflections on the saucepan lid and the knife and fork are unattractive.

CONSTRUCTION

A light tent is easy to make. Earlier in the book, very small tents made from halved table-tennis balls or egg shells were mentioned. The principle is the same for a larger tent.

The steps involved in constructing a tent are shown on page 59. Attach tracing paper or stronger translucent material to sturdy rectangular frames. The frames can be of wood, metal or plastic. A complete tent requires five pieces—four sides and a top. The base can be white paper or a translucent material that can be transilluminated.

If you're shooting color film, the tent material must be white. Otherwise, any color in the material would be seen as an overall cast in the picture. Also beware of using a colored base. Its color will reflect from the sides of the tent and give the entire subject a colored cast.

If you're not going to use a tent regularly, you can make an even simpler version. Simply roll a large sheet of translucent but reasonably stiff paper into a conical shape. Use adhesive tape to hold it in that shape. Cut the base of the cone into a uniform circle so the tent can stand flat. Then stand the tent over the subject like a teepee. You can cut a hole in the side of the tent for the camera lens. Or, you can shoot down through an opening in the top.

EXPOSURE

The best way to measure exposure with tungsten illumination is with a through-the-lens meter. With flash, the best way is with a flash/camera system that permits metering from the film plane.

You can also make a conventional incident-light meter reading. Remove the top of the tent. Hold the meter close to the subject in the tent, aiming the meter's hemisphere toward the camera lens. The reading you get should give you a good starting exposure.

Unless you're metering through the camera lens, it's advisable to bracket exposures to ensure a quality photograph.

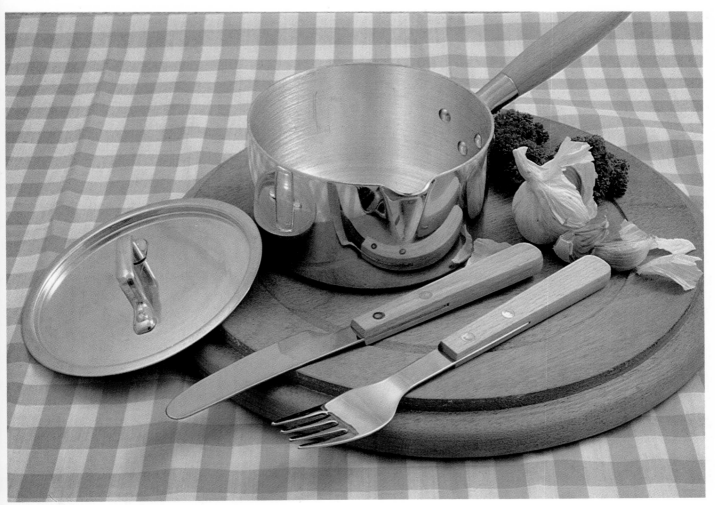

TYPICAL TENT LIGHTING

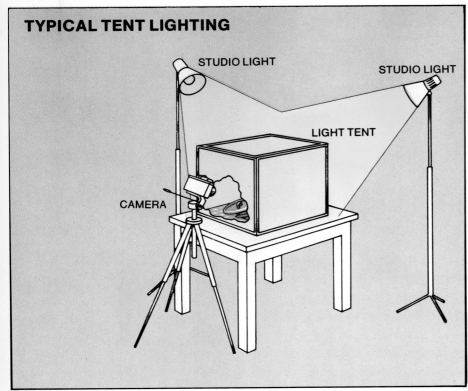

STUDIO LIGHT

STUDIO LIGHT

LIGHT TENT

CAMERA

WITH LIGHT TENT

The same arrangement as in the previous photo was photographed in a light tent. Two lights were used, as shown in the drawing. The white tent is reflected uniformly from the inside of the pan, the lid and knife and fork. The image looks much cleaner and less cluttered. Harsh shadows have disappeared.

The reflections on the outside of the pan come from within the tent. They can be avoided only by applying a dulling spray to the pan's side.

Backgrounds

The term *background* applies to both the area behind the subject as well as the base on which the subject stands. In still-life photography, the purpose of background materials is to isolate the subject from a cluttered or unsuitable environment. Background materials also enable you to select colors and textures that suit the subject.

SEAMLESS PAPER

Special photographic background papers are available commercially. They are usually in the form of seamless rolls of paper. Among photographers, the paper is generally referred to simply as *seamless*.

Rolls come in different widths, up to a maximum of more than 10 feet. For still-life work, you are rarely likely to need anything wider than a 52-inch roll. Individual sheets of background paper are also available, as are translucent background materials of various colors. For details of what's available, see your photo dealer.

How to Use Seamless—The best way to support and use seamless paper is shown on page 65. You should be able to place the roll at different heights and unroll the paper easily. Drape the paper over the table as shown. This way you get a continuous background and base, with no seam or break.

When a piece of seamless becomes soiled or damaged, simply cut it off and discard it. Pull down some clean paper from the roll and start again.

If the structures shown on page 65 are too complex for your purposes, you can simply staple a sheet of seamless to a stiff board and lean it against a wall.

OTHER BACKGROUNDS

A background can consist of any material that has a color and texture suitable for the subject. Among materials that may be appropriate are paper, cardboard, fabrics, tiles, grained wood, fur, cork and crumpled aluminum foil.

Black velvet is especially good when you need a pitch-black background. This material absorbs almost all light.

Background papers are available in a wide variety of colors. However, the paper comes in large rolls and is expensive. For still-life photography you generally don't need large backgrounds. If you look about you, you'll find many suitable background materials around the house or available from local stores. For versatility in your still-life photography, collect background materials of different colors, shades and textures. Avoid using unsuitable backgrounds. The kitchen foil, below, is a typical example. It detracts attention from the subject.

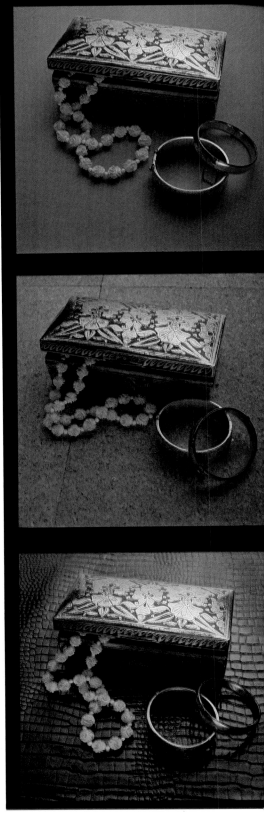

Top, right: Seamless background paper.
Center, right: Cork tiles.
Right: Imitation crocodile skin.

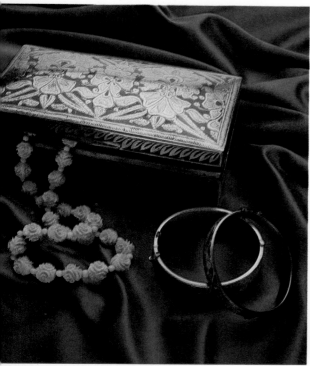

Velvet is a good background for jewelry. Choose a color that complements the subject colors. This kind of background is particularly effective when draped into folds.

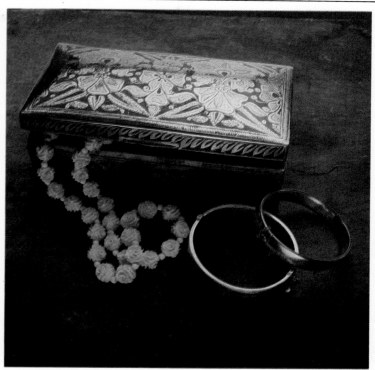

A piece of slate was used as background here. It adds a feeling of austerity that you may not consider appropriate for a jewelry photo.

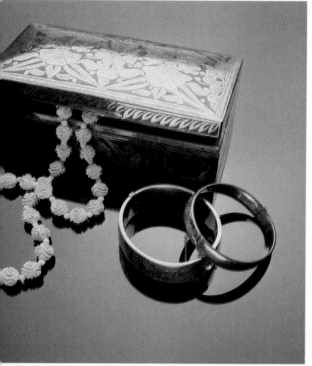

A shiny background, such as the Plexiglas used here, causes reflections that can give a photo added visual impact.

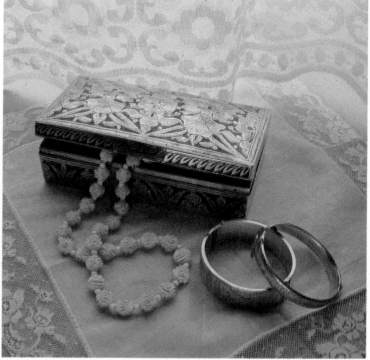

Lace on a green card and a lace curtain create the impression that the location for the photo was a dressing table in a bedroom.

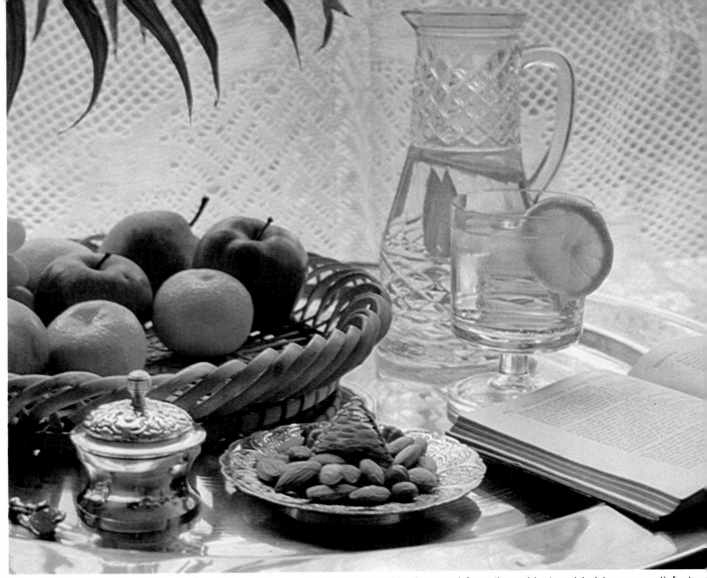

This still life was set up in front of a window. However, the scene outside detracted from the subject and led to an unsatisfactory composition. The lace curtain added a uniform background. It also softened the harsh window light.

Glass or Plastic Sheets—Transparent glass or plastic is often suitable as a base for the subject. Translucent materials can be lit from below to eliminate shadows and lighten the lower part of the subject.

Transparent sheets can raise the subject above a paper background. This enables you to project shadows from the subject beyond the picture area. It also enables you to control the background tone because you can light it separately.

LIGHTING THE BACKGROUND

Basically, you determine the background color by choosing a material of that color. Background tone can also be chosen directly. However, the lighting you use gives you continuous control of background tone. If you want the background to be lighter, put more light on it. To darken the

background, reduce background illumination.

To visually isolate a subject, you can direct a small spotlight on the background directly behind the subject.

Color From White Paper—You can convert a white background into a colored one by illuminating it with colored light. For example, to get a red background, place a red gel over the light illuminating the paper.

FOCUS CONTROL

Use depth of field to control background sharpness. If you want to clearly show the grain in wood or the texture in a fabric, stop the lens down to get the background sharp. If you want to obscure unattractive detail in a background, put it out of focus by opening up the lens aperture.

HOMEMADE STILL-LIFE BENCH

It's easy to convert an old table into a still-life bench. Cut three equally spaced notches into each of two pieces of 2x4 lumber. Fasten the 2x4s securely to the table, as shown. They'll hold a horizontal rod supporting the seamless paper. The top pair of notches should be at least three feet above the bench surface.

If the working surface is too high, shorten the table's legs. For a transparent or translucent base, cut a rectangular opening into the table surface. Place a sheet of glass or Plexiglas over the opening. If you want an opaque background, simply place a piece of wood over the opening in the table.

When using seamless paper, roll it down over the bench surface. This will give you a continuous base and background—without seam.

If you don't want to construct a bench, you can improvise with boxes, pieces of wood and vertical supports, as shown below.

Shooting Objects Around the House

The backgrounds discussed in the previous section enable you to separate still-life subjects from their surroundings. There is another kind of still life in which the natural environment plays an important part.

Look around your home and you'll find many themes for good photographs. You'll suddenly see attractive visual arrangements you've never noticed before. You'll also notice that the natural background is almost as much a part of the picture as the subject itself. To isolate the subject from the background with a sheet of seamless would spoil the picture.

In earlier sections of this book, we've mainly talked about *arranging* subjects for a photograph. In your home, you can *discover* subjects. But this doesn't mean that you can't rearrange the subject matter or slightly alter the background. However, the initial inspiration for the photo comes from an existing arrangement.

You can find subjects for still-life photos in every room of the house. They can range from neat table settings in the dining room to sections of a cluttered workbench or kitchen table.

COMPOSITION

As you look about you, you'll find small arrangements of things that appeal to you. In many, you'll see the potential of a good still life. However, the "set" is not likely to be perfect for photography just as you find it. You'll have to do some rearranging.

Feel free to move objects about, remove items or add things. Done thoughtfully, this can improve the picture without taking away any of the charm you originally saw.

Perspective—Before you shoot, try to see the still life photographically. To get the most attractive relationship between components in the scene, try different camera distances. The perspective between near and distant objects will be most marked when you come close. As you back away, objects will appear closer to each other and size differences will be less marked.

At close range, you'll probably need a wide-angle lens to get the entire setting into the picture. As you move away, use a longer lens to frame the image as you want it.

This still life was shot on a bathroom windowsill. All the objects were already there. The photographer simply rearranged them slightly. A steamed-up window provided excellent, soft, back lighting. The bright bathroom walls lightened the frontal shadows. In a high-humidity location like this, be careful that the camera lens doesn't steam up also.

BACKGROUND

Even though you should aim to use the natural background of the scene, that doesn't mean you shouldn't exercise control of it. Feel free to change the angle of view, if it will improve the background. Also, rearrange a drape or plant, if it'll make the set look better.

For example, the background may be a window. The visual effect will be quite different if the outdoor scene is seen through the window than when you have a backdrop of diffused light coming through translucent drapes. Decide which treatment suits the subject best.

Sometimes the entire background consists of the base on which the still life stands. A good example is the picture of the table setting, page 69. The table forms the entire background.

An effective background, but one that must be used with care, is a wall mirror. Be sure that you and your camera are not reflected back to the

You can even include your pet in a still life—provided the creature agrees to keep *still!* The illumination came from overcast daylight through a window. To warm up the bluish light, the photographer used an 81D light-balancing filter on the camera lens. The photo was taken with a 55mm macro lens.

...mera. Avoid all reflections from ...hts toward the camera. Don't show ...e reflection of unattractive subject ...rts, such as the backs of old picture ...mes. Be sure that those parts re- ...cted are lit attractively, both back ...d front.

To avoid unwanted reflections from ...ross the room, you may need a large ...rd or sheet of seamless in front of ...e subject. This way, you can limit ...e mirror reflection to the objects ...at are part of the still life.

LIGHTING

Remember that color-slide films are balanced specifically for daylight or tungsten light. Daylight-balanced films are also intended for use with electronic flash.

Don't Mix Light Sources—To avoid color imbalances, use the film intended for the illumination and try to avoid mixing light sources.

If your subject is lit by daylight through a window and you need more light from inside, use electronic flash.

Or, use a reflector card, if it will throw back sufficient light.

If you're using tungsten lights, avoid daylight. Darken the room when you're shooting.

Exceptions to the Rule—Sometimes the imbalance caused by using the "wrong" color film can actually be to your advantage. For example, if you want to record the warm glow of a room by tungsten light, use daylight-balanced film. With tungsten-balanced film, the colors would

Each of these photos was
made with soft back lighting
from a window. The frontal
shadows were lightened by the
reflection from a small mirror.
The composition for each shot
was planned carefully. The egg
in the foreground leads your at-
tention back to the other eggs.
The outer skin of the onion was
deliberately placed so it would
"contain" the onion.

This is a subject you can find in any home. However, to make an effective photograph you generally have to do some rearranging. The photographer carefully changed this table setting to achieve a subtle triangular composition. The place mat in the front forms the base of the triangle. The tip of the triangle is above the eggs, in the yellow flowers. The receding lines of the triangle give the picture a feeling of perspective and depth.

:ord more accurately, but much of e charm of the scene would be lost. If you want to record a still life by ndlelight, use daylight-balanced m. The scene will record distinctly ddish, but that's the kind of atmos- ere you associate with candlelight.

eflectors—Don't forget the useful- ss of reflectors. If you use them sely, you need no more than two ht sources to make high-quality ll-life photos. Matte white reflectors can brighten shadows. Foil reflectors and mirrors can play the role of secondary light sources.

Sometimes a tent will provide the best illumination for a still life. To retain the natural background, leave the back of the tent open.

Diffuse Light—If direct illumination from your flash or tungsten light is too harsh, you can diffuse the light by placing a translucent piece of material in front of the light source. Or, you can bounce the light. Aim the light at a white card in such a way that the re- flected light illuminates the scene.

TRIPOD

With tungsten light and daylight, exposure times are likely to be so long that a tripod is essential. With flash, handholding the camera is possible. However, having the camera on a tripod makes composition much easier. If you want to change the camera viewpoint slightly from shot to shot, a tripod-mounted camera gives you much more accurate control.

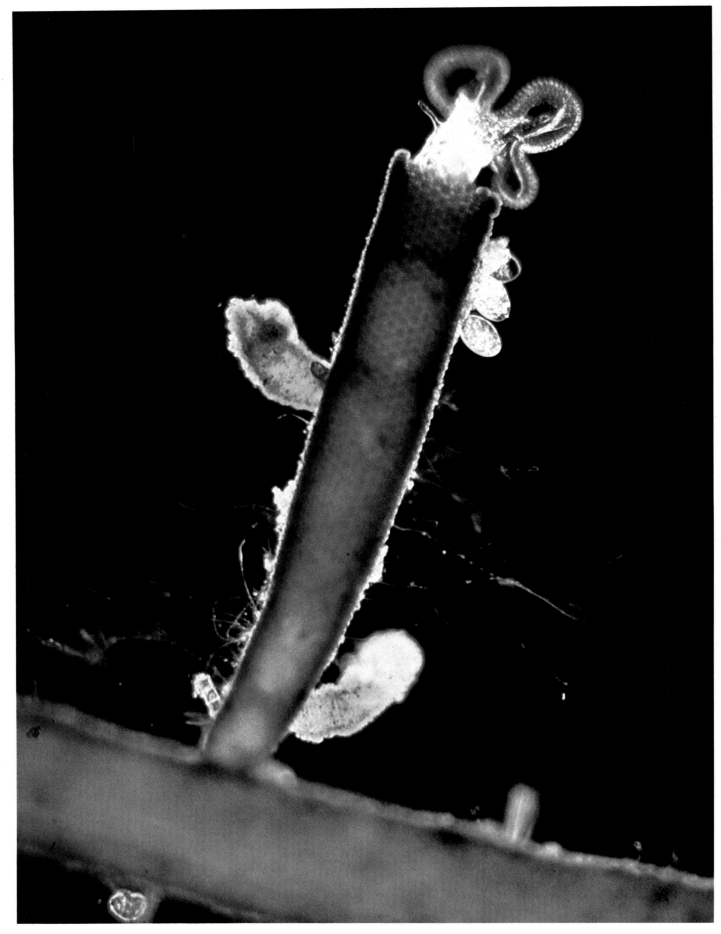

PHOTOGRAPHY THROUGH A MICROSCOPE

Photography Through A Microscope

To photograph a subject at a higher magnification than is possible in the macro range, you need a microscope. Photography through the microscope is called *photomicrography*. The subject photographed is generally called the *specimen*.

With a good microscope and high-quality lenses, you can achieve fine images at magnifications up to 1000. Even with a simple student microscope, you can get good images at magnifications up to 200.

How is this high magnification possible? In macro photography, you rely on one lens to provide the magnified image. When you use a microscope, you get the ultimate image by magnifying the specimen twice.

A microscope has two lenses—an *objective lens* and an *eyepiece*. The objective lens, which is nearest the specimen, produces a magnified image of the specimen in the microscope tube. The eyepiece at the top of the microscope tube picks up this first image and enlarges it again.

To see the image of a specimen in the microscope, you look through the eyepiece. To photograph a specimen, you attach a camera to the microscope.

THE MICROSCOPE

The illustration on this page shows a typical microscope. Let's examine the various parts:

Tube—Image formation takes place in the tube. At the lower end of the tube is a lens turret. At the top end is the eyepiece.

Objective Lens—The lens turret contains three objective lenses. Each of these lenses is designed to give a different magnification of the specimen. An image of the specimen is projected by the objective lens into the tube. If the objective lens is a 20X lens, the image will have a magnification of 20.

Eyepiece—At the top end of the tube is the eyepiece. You look through it to see the microscope image. The eyepiece also has a specific magnifying power. If an 8X eyepiece picks up an image made by a 20X objective lens, the total image magnification will be $20 \times 8 = 160$.

Stage—The stage, or specimen stage, is a platform where the specimen is held in place. The stage surface is perpendicular to the tube axis. It should be sturdy and should have a device that allows the specimen to be moved smoothly in a horizontal plane.

Expensive microscopes have micrometer scales that enable you to return easily to a specific location of a specimen. On a simple microscope, you may have to move the specimen under the objective lens by simply pushing it with your fingers.

Illumination—The light source for the microscope comes from below the specimen. Complex microscopes have built-in illumination. Relatively simple microscopes, like the one shown, rely on a separate light source. The ideal separate source is a *microscope illuminator,* available from microscope supply houses. However, other types of lamps, such as high-intensity desk lamps, can also be used.

A mirror near the microscope base reflects the separate light source up toward the specimen.

Substage Condenser—Between the specimen and the light source or mirror is the substage condenser. It can be focused and its aperture can be adjusted.

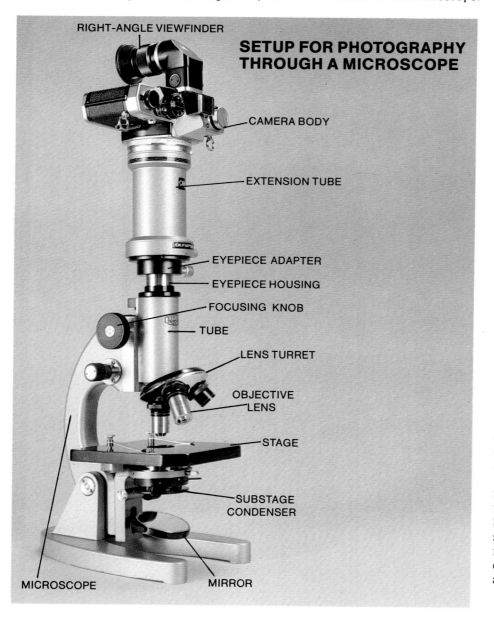

RIGHT-ANGLE VIEWFINDER

SETUP FOR PHOTOGRAPHY THROUGH A MICROSCOPE

CAMERA BODY

EXTENSION TUBE

EYEPIECE ADAPTER

EYEPIECE HOUSING

FOCUSING KNOB

TUBE

LENS TURRET

OBJECTIVE LENS

STAGE

SUBSTAGE CONDENSER

MICROSCOPE

MIRROR

Photography through a microscope reveals the usually hidden beauty of nature. This detail of a pheasant feather was recorded on film at a magnification of about 60.

Use the condenser to focus the light source as indicated in the instructions with your microscope. Doing this correctly is important. Image quality depends on it.

For most photography, the condenser aperture should be stopped down about one third of the way from wide open for best image quality. If it is left open too wide, image contrast may be insufficient. If it's closed down too far, the image will deteriorate because of an optical phenomenon called *diffraction.*

READ MICROSCOPE INSTRUCTIONS

It's impossible, on these few pages, to tell you everything about your specific microscope or about microscopy in general. The purpose here is to show you the basics of taking photographs through a microscope.

To get the best results, be sure to read carefully the manual supplied with your microscope. If you want to know more about microscopy in general, or about specific techniques, visit your local library or a local book store for more detailed literature.

Several microscope manufacturers, including Ernst Leitz and Carl Zeiss,

produce booklets you may find useful. Consult your microscope supplier.

One book that treats the subject of photomicrography extensively and clearly is *Photomicrography—A Comprehensive Treatise* by Roger P. Loveland. It comes in two volumes and is published by John Wiley and Sons, Inc.

IMAGE MAGNIFICATION

The magnification you see through the microscope isn't necessarily the same as the one you photograph. Let's examine both magnifications to find out what happens in each case.

Visual Magnification—The product of objective-lens magnification and eyepiece magnification gives you the total image magnification. For example, as discussed earlier, a 20X objective lens and an 8X eyepiece give a total visual magnification of 160.

Photographic Magnification—The image you see through the microscope is about 10 inches (250mm) from the eyepiece. This is about the distance at which you would normally read a book or look at a photograph. To photograph this image at the size you see it, you need an eyepiece-to-film

distance of 10 inches or 250mm.

If the extension tube, shown in the illustration, provided an eyepiece-to-film distance of 10 inches or 250mm, the setup shown would give the magnification you actually see. A 10X objective lens together with an 8X eyepiece would give a total magnification of 80—visually or on film.

Most amateur photographers will not use an extension tube. They will simply add the camera to the microscope. This gives an eyepiece-to-film distance of about 50mm. The photographed image will be smaller than the viewed image. The magnification will be reduced by a factor of 50mm/250mm , or to 1/5 the magnification you see.

The following formula enables you to determine actual image magnification on film. When the magnification on film is M, the objective-lens magnification is M_o, the eyepiece magnification is M_e and the eyepiece-to-film distance is d (in mm):

$$M = (M_o \times M_e) \times d/250mm$$

For example, if you have a 20X objective lens, a 6X eyepiece, and the SLR is attached to the microscope without extension:

$$M = (20 \times 6) \times 50mm/250mm$$
$$M = 120 \times 1/5 = 24$$

The total magnification on film will be 24. The visual magnification, by comparison, will be $20 \times 6 = 120$.

If you enlarge or project the film image, the final magnification will be the magnification on film multiplied by the enlargement factor. For example, if you enlarge a film image of magnification 24 by a linear factor of 5, the total image magnification will be $24 \times 5 = 120$.

CAMERA LENS OR NOT?

The only 35mm camera that lends itself to photomicrography is the SLR. That's because you must be able to see the image that will appear on film. With a separate viewfinder, you would have no idea what the film is going to record.

Strange as it may sound, although you need an SLR camera, you don't need the lens itself. In fact, you're better off without it.

Here's why: Microscope objective lenses and eyepieces are designed to complement each other optically. Optical aberrations are excluded not simply from each lens but from the combination of lenses. If you were to add another lens—the camera lens—that's not part of this optical system, image quality would almost certainly suffer.

The two microscope lenses are perfectly capable of projecting an image onto film without the aid of a camera lens. So, it's best to leave the camera lens off the camera.

If you want to use the camera lens, however, you may do so. You can still take a picture through the microscope.

FOCUSING

The focusing techniques with and without camera lens are a little different.

Without Camera Lens—Adjust the microscope focus while looking through the camera viewfinder. When you see a sharp image, you're ready to take pictures.

With Camera Lens—First set the camera lens to infinity. Then look through the viewfinder. Focus the microscope until you see the sharpest possible image. You're ready to take pictures.

ASSEMBLY

The microscope should stand on a sturdy bench or table. The camera, without lens, can be attached to the microscope or microscope extension tube with a special adapter. For details, ask your microscope supplier or your photo dealer.

Alternatively, the camera can be mounted separately on a suitable stand. A copy stand, or an enlarger column—without enlarger head—are ideal. Camera and microscope should not touch each other but be about 1/8 inch apart. To exclude ambient light, you'll need a light-tight collar where microscope and camera meet. The collar could be made of black paper, tape, velvet or of metal. This mounting method is suitable for a camera with or without lens.

STURDINESS

Having read this book so far, you are well aware of the importance of equipment sturdiness when producing magnified images. This is no less true when you're using a microscope. Although the microscope is an integral optical and mechanical unit, there's still a possibility of equipment vibration. And remember, image magnifications are much higher than in the close-up and macro ranges. Avoid areas that are subject to vibration or movement and use a sturdy bench or table for your microscope.

COLOR BALANCE

Microscope illuminators are generally tungsten lamps. The light intensity can be adjusted. For greatest viewing and focusing comfort, you'll generally want to set the brightness fairly low. However, if you're using color-slide film, to get the proper color temperature you should set the intensity at its brightest setting for photography. Use a tunsten-balanced film. If you use a daylight film, use corrective series-80 color conversion filters.

If the microscope has a filter holder, place filters there. Otherwise, the best location is in front of the light source. Do not place filters immediately above or below the specimen stage.

If you use tungsten illumination for focusing and electronic flash for exposing film, shoot on daylight-balanced film.

EXPOSURE

If your camera has through-the-lens (TTL) metering, base your first exposure on the meter reading. There are special separate light meters that take readings through a microscope. An example is the Gossen Luna-Pro, shown on page 57. It has a special Luna-Micro attachment. Whichever method you use, bracket liberally, at least two steps in both directions, in half-step increments.

If your camera doesn't have a meter, you'll have to estimate the first exposure. Again, bracket liberally.

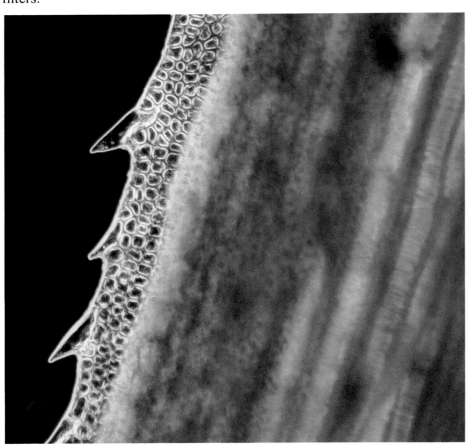

Citric acid crystals, photographed between crossed polarizers. By changing the rotation of one polarizer, you can achieve a wide variety of colors and tones.

Dark-field illumination revealed the edge detail in this hair-moss leaf. Magnification on film was about 250.

A few drops of pond or ocean water contain many tiny organisms such as this. Allow a drop of water to evaporate on a glass slide. This slows down the motion of the organism. Darkfield illumination revealed the internal structure of this specimen.

SPECIMEN

We've discussed the various steps and principles involved in making a photograph through a microscope. But we haven't told you *what* you can photograph.

Buy Slides—A wide selection of microscope specimens, professionally mounted on slides, is available. Ask your microscope supplier for details.

Prepare Your Own—Some specimen types are easily made at home. All you need is some clean microscope-slide glasses. For some specimen types, you'll also need cover glasses and a suitable cement. You can also stain your own specimens so as to make them more visible in the microscope. For details on materials and techniques involved, ask your microscope supplier.

Here are just a few examples of easily prepared specimens: Allow a drop of pond water to evaporate on a slide. The dried residue should reveal some interesting things about the water. With a tiny pin prick on your finger tip, you can produce a smear of your own blood on a slide and examine it at high magnification. Or, dissolve table salt in water. Permit the solution to dry on a microscope slide. Examine the crystallized result.

Polarized Light—Crystalline residues, such as the salt deposit just mentioned, often reveal beautiful color patterns when viewed by polarized light.

Place a piece of polarizing material below the substage condenser. Place a second polarizer on top of the eyepiece. While looking through the eyepiece, rotate one or both of the polarizers. You'll see some beautiful color patterns. When you like what you see, attach the camera and shoot.

EXPERTS AT WORK

Mike Newton— Tableware & Food

Mike Newton is a professional still-life photographe
He specializes in the photography of tableware, glass an
food. The photographs on the next six pages show why h
talents are in great demand in his native England.

A visit to Mike's studio reveals him to be an orderl
person. Everything is in its proper place. He works in a tid
and organized manner. Yet, there is something highly in
tuitive in his creative energy. This easy, spontaneous ap
proach to his work stems from his pragmatism and man
years of practical experience.

There's an austerity about Mike's approach to his pho
tography that's both charming and thought-provoking
For example, he believes in getting to know a couple o
films, developers and paper types thoroughly and the
relying on them—unless something with different charac
teristics is specifically called for.

Mike has summed up this attitude very graphically b
saying, "Photography is not about discovering the lates
developer from Afghanistan or a new miracle lens coatin
from North Korea."

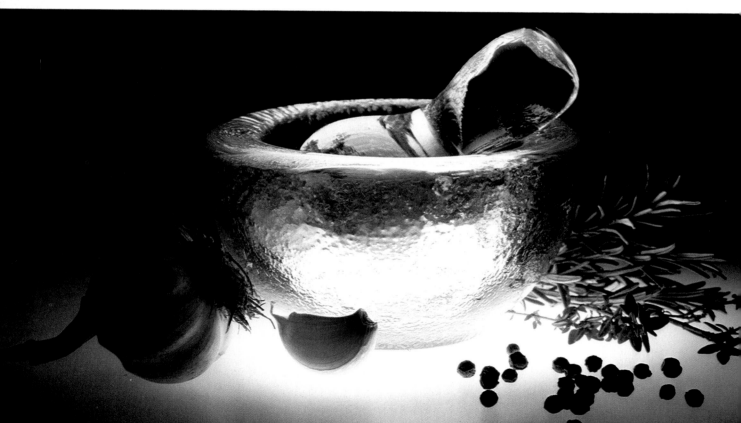

▲ The subject was placed on Plexiglas and lit from below. This
revealed the texture in the glass bowl. The subillumination also
provided just the right amount of detail in the garlic and herbs,
which were added to indicate the size of the bowl and pestle.

▶ When photographing tableware, especially for commercial use
it's important to record the colors correctly. Pastel colors and white
are easily affected by the reflection of other colors. Avoid brightly
colored objects at locations where they could reflect unwanted
color onto the tableware. The backlit parasol was carefully placed
behind the subject. Its orange color is reflected only in the spout
and lid of the teapot. If the parasol had been higher, it would have
given much of the subject an unwanted orange color cast.

The technological wonders of photographic equipment, materials and processes don't fail to impress Mike. However, he regards the practical business of photography as very much a vital, animate activity. He likes to remind us of this in a very basic, graphic way by referring to the gelatin base of film as "cow's bones and marrow—not inanimate."

IMAGE COMPOSITION

With Mike, image composition and lighting go hand in hand. He doesn't complete the placement of all objects before giving any thought to the effect the illumination is to produce. It's like playing the piano with both hands. If you played first with the left hand and then with the right, the result would not be what the composer had in mind.

Props—These are the accessories and bits and pieces that a photographer adds to the subject. Their purpose is to put the subject in a believable environment, to give the impression that the subject is being used, or to simply make the picture more attractive.

Props are an important component of a still life. You can see plenty of props in the photos in this section. However, Mike points out that it is important not to permit the prop to become the subject. That, he explains, is why his photos featuring glass are quite different from his photos advertising wine.

PHOTOGRAPHING GLASS

Mike is always in demand for his special abilities in photographing glass. He produces a lot of catalog illustrations.

Glass presents a photographer with special problems. Its transparency allows it to be lit from front, side, back, below or above. To achieve the most effective result, a combination of light from various directions is sometimes called for.

Special consideration must be given to background selection, because you can see it through the subject. White, black or translucent backgrounds all produce specific results with glass objects.

When glass is textured or engraved, a slight movement of the light can make the difference between revealing or concealing detail.

Carefully study the photos on pages 78 and 83 and their captions. Try to visualize how the lighting and background selection in each case affected the detail recorded.

PHOTOGRAPHING TABLEWARE

Subjects like the tableware shown on page 79 are often best lit with a large diffuse source or in a light tent. In the photo on page 79, notice the absence of bright catchlights and deep shadows. This softness not only flatters the objects but also shows them with the greatest detail. Notice also the effective use of the backlit parasol as a prop.

A good food photographer has to be resourceful. Mike Newton was asked to produce a photo of fish and mussels for a French cook book. Mussels were out of season, so canned ones were painstakingly fitted into the shells. The camera view was vertically downward. This enables the photo to be viewed in virtually any direction. Try it—it looks OK sideways or even upside down.

FOOD PHOTOGRAPHY

With food photography, preparation is usually more time-consuming than the photography. The photographer must work in close harmony with a food specialist and stylist. It's the stylist's job to make the food look right and appetizing. The photographer must record the result without losing any of the "magic."

Mike's aim is to record food so it looks tempting. The photo must elicit the delicious aroma of the dish. The viewer must almost be tempted to dig into the photo with knife and fork—even though the use of petroleum jelly or shaving cream to simulate fat or whipped cream may have made the dish totally inedible!

LIGHTING

Mike likes to use tungsten light. It gives him better visual control than the modeling lights built into his flash units. He also believes tungsten light gives his images an indescribable light quality that is missing with flash.

However, Mike will be the first to recognize the values of electronic flash. Short duration and high light output are obvious ones. An equally important asset, especially in certain applications, is the absence of heat.

All of Mike's food photography is done with flash. Subjects that include plants or flowers are shot with flash. On occasions when live models or stylists have to work under the lights for many hours, Mike prefers to use flash. As he says, heat makes the photographer tired, his models and assistants short-tempered, plants and flowers wilt, and food appear unappetizing.

Mike likes to illuminate some suitable subjects with soft, diffused daylight—when it clearly provides the most effective illumination. However, he finds the variability o the light's brightness, color and softness a problem an generally avoids it.

COLOR BALANCE

Accurate color balance, especially in his photography c tableware, pottery and fabrics, is very important to Mik The client wants his product depicted accurately. Colc plays a large part in the design of a piece and is chosen wit care. It's important that the prospective customer sees th colors as they actually are.

To ensure accurate color reproduction, Mike spends lot of time testing film batches. He'll shoot a subject and color-rendition chart, such as the Macbeth ColorChecke If a color imbalance in the processed result indicates th need for filtration, he'll make further tests with filter When he gets correct color balance, he makes a note of a exposure and lighting data and the filtration used. He use this information while using that particular film batch.

In food photography, Mike says, accurate color is nc essential. The main thing is for each dish to appear both a believable and appetizing as possible. This may call fc slightly different filtration for each subject. The only wa to determine what works best is to make test exposure: Examine the images after processing, and make any nece: sary changes in lighting, exposure or filtration.

THE ATTRACTION OF STILL LIFE

One aspect of still-life photography that Mike finds mo attractive is the absolute control it affords him. The sti life is totally obedient. It stays where it is put until h moves it. It doesn't frown when it's supposed to smile, c

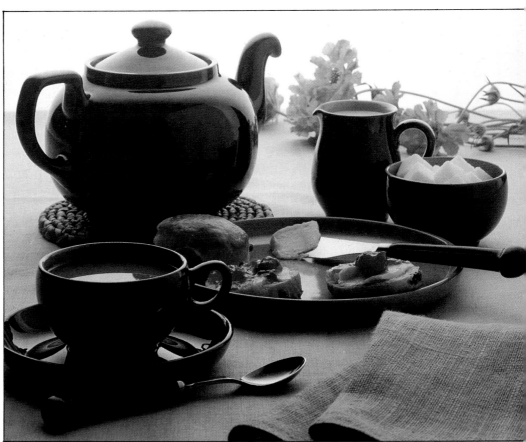

Most of the illumination on this Denby pottery came from a soft light source above the subject. It provided the highlights on top of the teapot, on the tea in the cup and the other horizontal surfaces. The background was backlit Plexiglas. The props were chosen to harmonize with the muted colors of the main subject.

Light reflected from the white background provided the only illumination. The coarse grain was achieved deliberately with the use of fast Royal-X Pan film. The silhouette effect was exaggerated by printing the negative on contrasty paper.

In his spare time, Mike Newton likes to photograph landscapes and scenic views. His photos rarely contain people. The unchanging landscape offers Mike almost the same total control he has with static still lifes.

bend when it's supposed to be straight. It remains its unalterable self.

This gives Mike total control to create the image he wants. He can change the position of the subject. He can alter the background, add props, change the lighting and make many exposures. He can go to the darkroom, or even send film to the lab, and return to an obedient subject—still sitting there.

DIVERSION

From the exacting work he does in his studio, Mike Newton needs an occasional diversion. What do you think he does on his days off? He takes photographs! Not still lifes, but mainly landscapes and scenic views. However, most of his leisure photography has something in common with his studio work. His pictures rarely contain people.

The subject remains relatively still and he can mold it into the precise image he wants!

Tessa Traeger— Creative Food Photography

Tessa Traeger, whose photographs first appeared in *Vogue* several years ago, is a food photographer with a difference. It's not her primary purpose to show food at its most tempting and delicious. At least not to the *consumer*. Her food pictures are directed at the *observer*. As the photos in this section show, Tessa's artistic medium is food as the painter's is paint and canvas.

CREATING THE IMAGE

Tessa probably spends more time working with the food than with her camera. When she's satisfied with the *food* image, she turns to her camera and produces the *photographic* image. To her, making the exposure is the final confirmation and culmination of her artistic work.

TRANSIENT SUBJECT

There's a special fascination for Tessa in working with a medium she knows to be transient. In this respect, imagery with food is similar to sculpture with ice. The artist does it with great love although—or because—it will not last long.

There's the comforting thought, however, that the work of art can be retained indefinitely through photography. Tessa's photos can be appreciated year after year, although the original work may have perished after only days. That gives Tessa's photography purpose. "Why," she asks, "photograph a collage of fabric, stone or beads? The original itself will keep for years!"

BACKGROUND

In Tessa's photographs, background and foreground are so integrated that it's often difficult to tell where one ends and the other starts. Frequently, her background is a painting. The backgrounds are carefully selected to harmonize in color and tone with the foreground subject.

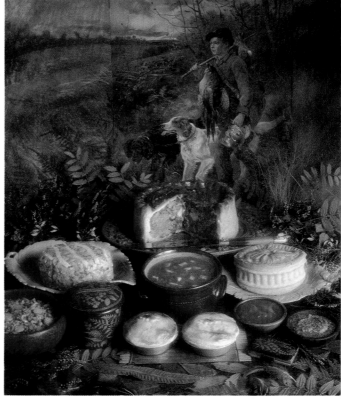

▲ The food and the painting seem to form one continuous scene. Tessa carefully combines foreground and background themes and colors that harmonize. The soft illumination was provided by flash reflected from an umbrella.

▶ Tessa made this copy of a Botticelli face with marzipan and food coloring. To minimize shadows, she photographed the result with diffused flash.

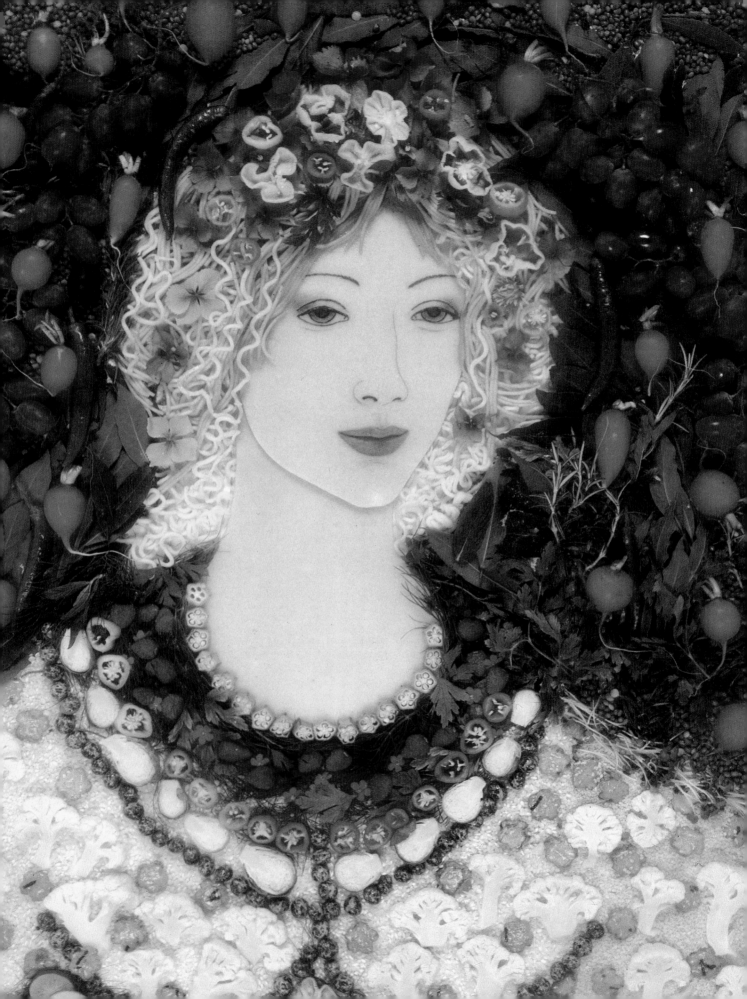

DISHES

Tessa gives careful consideration to the shapes and textures of dishes and how they will interrelate with the remainder of the subject. The dishes she chooses are often indicative of the food involved. For example, a dish shaped like a boat or shell is likely to be used for seafood.

She arranges the dishes first to achieve a pleasing composition. Then Tessa chooses an appropriate background. The food is the last thing to be added.

ONLY THE REAL THING

Tessa Traeger might be described as a purist in her work. All the food she depicts is real. Ice cream is ice cream—not mashed potatoes. Whipped cream is exactly that—not shaving cream.

The food is never wasted. When the photographic image is safely on film, all edible parts of the work of art are shared and devoured while they are still delicious!

GOT ANY IDEAS?

You may wonder why we're telling you the unusual story of Tessa Traeger and her work. After all, not many photographers work in her "medium." The answer is simple: We want to show you that, in photography, the only thing that can limit your creativity is your own imagination!

▶ Is the food real and the girl on a painting? Or is the girl real? Perhaps the whole thing is a copy of a painting! Tessa chooses colors and lighting very carefully. Here, she succeeded in blending the painting of the girl with the real food very effectively.

▶ Tessa spends more time preparing her food "art" than photographing it. A lot of patience and imagination are expended before she's ready to set up her camera. In the case of these eggs, most of her effort went into finding a sufficiently varied selection. To get the shapes, sizes, colors and patterns shown here, Tessa had to borrow from several collectors.

▼ This mosaic of vegetables and fruit was prepared on a sheet of white paper. Tessa planned the approximate design in advance. She then carefully built the mosaic, piece by piece. Because it was a slow process, Tessa put the less durable food items in place last. The result was photographed under uniform, soft illumination to produce a shadow-free image.

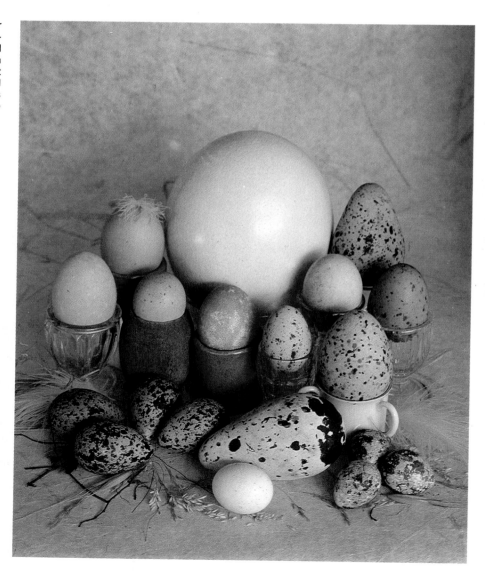

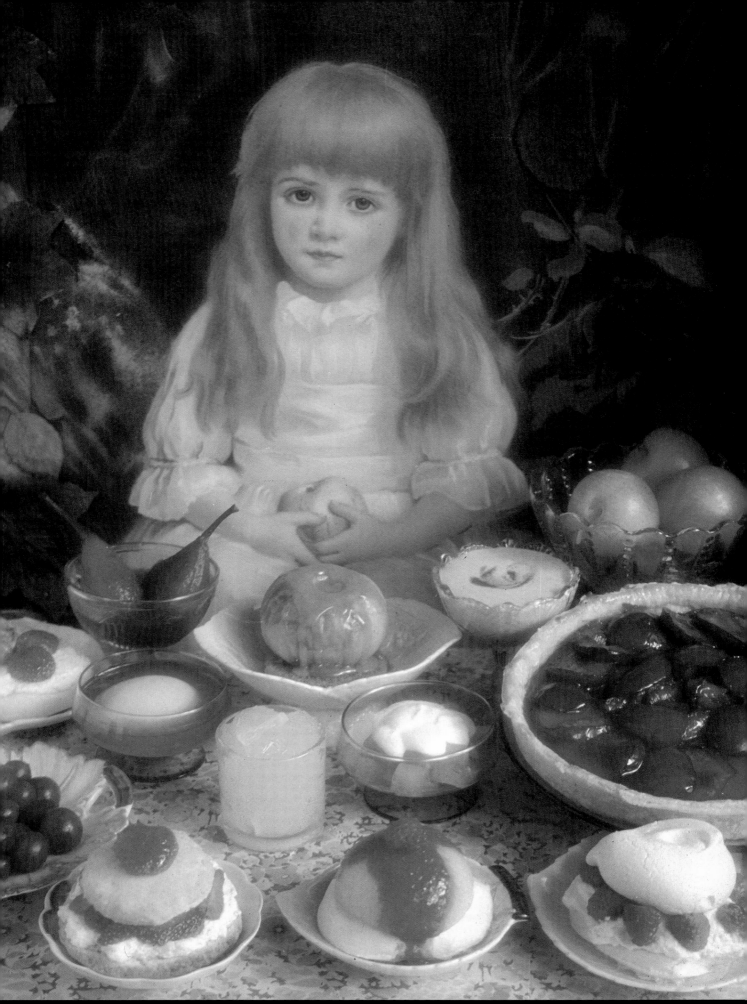

Ed White— Startling Still-Lifes

When you look at the photographs on the next three pages, you'll quickly realize that Ed White is much more than just a photographer. Foremost, he is a *creator* of still lifes. When they are complete, he *photographs* them. In this respect he can be compared to Tessa Traeger, who creates with food. Ed describes himself as an illustrator—a director of ideas.

Whatever his title—photographer, illustrator, director—we considered his work sufficiently outstanding to include in a book concerned with close-up and still-life photography.

LIGHTING CONTROL

Ed works slowly and builds up his images with careful deliberation. Nothing is left to chance. A painter starts with the white surface of a canvas and adds colors. Ed starts with total darkness and adds light. He works almost entirely with electronic flash.

Black Studio—To help him, every surface in Ed's 35x40-foot studio—even the floor—is painted black. You'll notice from his photos that Ed has remarkable control, not only of his lighting but of the exclusion of light. He can light the subject exactly as he wants and yet retain darkness where it's called for.

In addition to the black surroundings, Ed has other helpful tools. They include the following:

Booms—Most of Ed's lights are on booms— counterbalanced extension arms. They enable him to place lights virtually anywhere. He can illuminate the subject from the front or side. He can introduce light from the back without getting the light stand into the picture. With the help of translucent material, he can light the subject from below.

Barn Doors—These are flaps attached to the front of a light. They can be adjusted to control precisely the part of the subject that is to be lit. Barn doors shield those subject areas that are to be unaffected by the light.

Adaptability—This is a key word in Ed's lighting technique. Frequently, his lighting is specially tailored to achieve a specific effect. Rarely are his lights used as designed by the manufacturer. With adhesive tape, string, diffusers and homemade baffles, Ed's lights are custom-adapted for each specific purpose.

PERSPECTIVE

A continuous challenge for photographers is to translate a three-dimensional scene into a flat photograph without losing the feeling of depth or distance. It calls for the effective use of perspective. Near objects must appear near and distant ones must look far away, even on the flat photograph.

Ed achieves convincing perspective by carefully selecting his camera position. However, he goes further. He *creates* the feeling of depth in various ways.

Exaggerated Perspective—Parallel lines that recede from the line of view tend to converge. To exaggerate perspective, Ed sometimes makes lines converge more than they normally would.

The photo on page 91 is a good example. The boards used did not have parallel sides but were tapered. This helped in the photography in a couple of ways. First, the distance appeared much greater than it actually was. Second, because the real scene was much shorter than the apparent scene, depth-of-field requirements were not as great.

To make the distance effect more realistic, Ed carefully chose wood with grain structure that became smaller at the narrow end of the boards.

Perspective or distance can often be suggested rather than real. All the photos on pages 90 and 91 have an artificial sky background. This provides each image with a great sense of depth—although the actual background was just a few feet from the camera.

EXPOSURE

Ed uses mostly Ektachrome 64 film. He bases exposure on careful meter readings and numerous Polacolor test exposures. Having found the "right" exposure, Ed brackets one half step to each side.

Ed guards carefully against overexposure. He likes highlights and midtones with detail and rich, deep shadows. To get the powerful visual statement he wants, Ed says his "ideal" exposure usually involves underexposing by about one half step.

THE ASSISTANT SHOOTS!

"Show biz" people are well-known for their quaint superstitions. You don't often hear of superstitious photographers. However, Ed White is one. He sets up everything, makes all the test shots and determines optimum exposure. Then he lets his assistant take over. She shoots the Ektachromes! Ed considers it bad luck to be in the studio when the picture is taken. He says, "There's your headline—*The Photographer Who Won't Touch His Camera!*" We think he does a fine job anyway!

Ed made this effective image with just one light source. It was placed low behind the white translucent background of Plexiglas. A reflector card was used to produce the frontal highlights in the metal without adding too much frontal detail elsewhere. Because Ed wanted the tulip to reproduce in total silhouette, he specially had an artificial one made from wax.

Each of the photos on these two pages has a sky background. It gives the images a feeling of depth. It also adds a feeling of mystery and drama.

Cloud images on 35mm film were enlarged to produce five-foot wide transparencies. Each of these was mounted on Plexiglas. One was placed behind each subject. These backgrounds were transilluminated by flash. Colored gels were used on the flash to produce the desired color effect in each background.

To make each photo, the studio was darkened totally. While the flash exposure of the subject was made, Ed covered the background with black velvet to avoid reflections. To add the background, the black velvet was removed and the flash was fired through the large transparency. To get sufficient light through the sky transparencies, the flash had to be fired 10 to 18 times. The exact number depended on the filter gel used.

▶ Ed lit the subject from directly above. This provided good modeling for the wooden apple and produced attractive highlights on the knife. The wooden base reflected enough light to provide shadow detail. To darken the distant part of the scene, Ed carefully adjusted a barn door on the light to shield that part.

▼ This photograph was made in three stages: 1) The wooden egg was illuminated at a very low angle from a slide projector. An 80A color-conversion filter was used to balance the tungsten light for the daylight-balanced color film used. Wearing a black glove so the image of his hand would not record, Ed slowly pushed the egg to the left during a time exposure. This produced the blur. 2) Ed removed the filter and exposed the saw, egg and egg shell with diffused flash. 3) The protective black velvet was removed from the background. Then 12 consecutive flashes were given through the background transparency. A brown filter gel was used on the flash to create the storm effect.

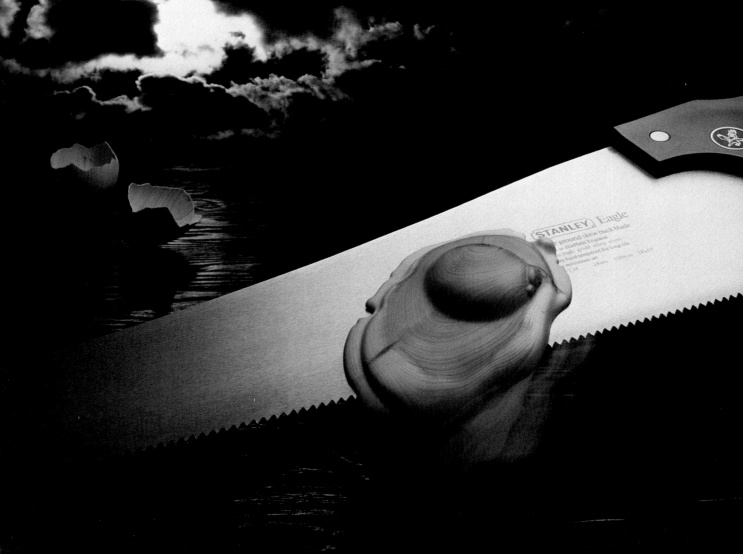

Much of this shot's impact comes from the dynamic perspective. The boards were less than three feet long but seem much longer. To achieve the effect, the boards were tapered. Also, Ed selected boards with tighter wood grain at the far end. To exaggerate the perspective even more, Ed used a wide-angle lens. The hammer was suspended from a boom, just outside the picture area.

John Walsh— Photographing the Microscopic

When he's not out collecting polluted pond water or moldy bread, John Walsh is most probably behind his microscope. He examines and photographs subjects—known among microscopists as *specimens*—that are virtually invisible to the naked eye.

John's versatility is part of the key to his success. He is as comfortable with a still camera or movie camera on his microscope. He enjoys working with dead or living specimens. If the right illumination for a specific job doesn't exist, he'll invent or convert something.

An easy way to photograph living and moving specimens is to sedate them with a drug such as *chloral hydrate*. This makes it possible to get sharp pictures of many specimens at 1/100 second exposure. That's a practical exposure with a tungsten-halogen microscope illuminator.

John prefers to shoot his ''subjects'' in full possession of their faculties. This calls for electronic flash.

ILLUMINATION

Photographers have used electronic flash for decades. Its use in microscopy is much less widespread. This is largely because it's difficult to place a tungsten modeling light and a flash tube in precisely the same place.

Standard microscope illumination, known as *Koehler Illumination,* must be centered and focused precisely to yield a satisfactory image. By using a tungsten light for viewing and focusing, it's impossible to subsequently center and focus the flash used for photography.

Homemade System—To overcome this problem, John has adapted available equipment. He built a flash tube into a regular microscope illuminator. The tungsten viewing lamp and the flash are focused through the same condenser system. This gives John a reliable ''modeling light.''

Strobe for Movies—For making movies, John has had a special strobe flash built that fires in sync with his 16mm movie camera. Among other projects, he's used this system to make a film on bacteria for the Australian Broadcasting Commission.

DEPTH OF FIELD

Microscopists who photograph thin sections or smears, mounted on glass slides, have few depth-of-field problems. Depth of field, even at a magnification of 1000, is usually great enough to encompass the specimen thickness. With live specimens that have considerable thickness, however, greater depth of field is called for.

You can't stop down the optical system to gain depth of field as you would in a camera. The only alternative way to get the needed depth of field is to work at a lower magnification. John believes in keeping the microscope magnification down to a practical level. If he wants a larger image, he'll enlarge the picture made in the microscope.

START AT LOW MAGNIFICATIONS

John advises newcomers to microscopy to begin by limiting their work to magnifications no higher than about 100. Within this range, there's relatively good depth of field. John also points out that lamp alignment and focus, as well as other microscope adjustments, become more critical as magnification goes up.

By the time you reach magnifications of about 1000, you generally need *oil immersion*. This means that, to retain optical quality, the space between objective lens and specimen must be filled with a special immersion oil. Don't try this until you're thoroughly familiar with your microscope and its basic operation.

When you think you're ready for high-magnification work, follow the directions provided with your microscope lenses and condensers and with the immersion oil.

CAMERA

John uses a Nikon camera, without lens, for his photography through the microscope. He mounts the camera on a copy stand. The camera is lowered to within about 1/8 inch from the microscope eyepiece. John carefully avoids contact between the two instruments. He points out that this is important to avoid the danger of specimen vibration due to the operation of the camera shutter. To exclude light from the microscope/camera connection, John uses an improvised black collar.

THE ADVENTURE OF MICROSCOPY

To John, photomicrography is as exciting as going on a photo safari in Africa. He once trapped a *trichocerca* in a sample of pond water. He observed it swimming through the water for two days and took pictures of it nibbling at filaments of algae.

On the third day, the creature wasn't to be seen anywhere. It couldn't have escaped—there was no way out. In the same specimen of water, John observed a tiny worm. On closer scrutiny, he saw the trichocerca inside the worm! That made for another exciting photograph!

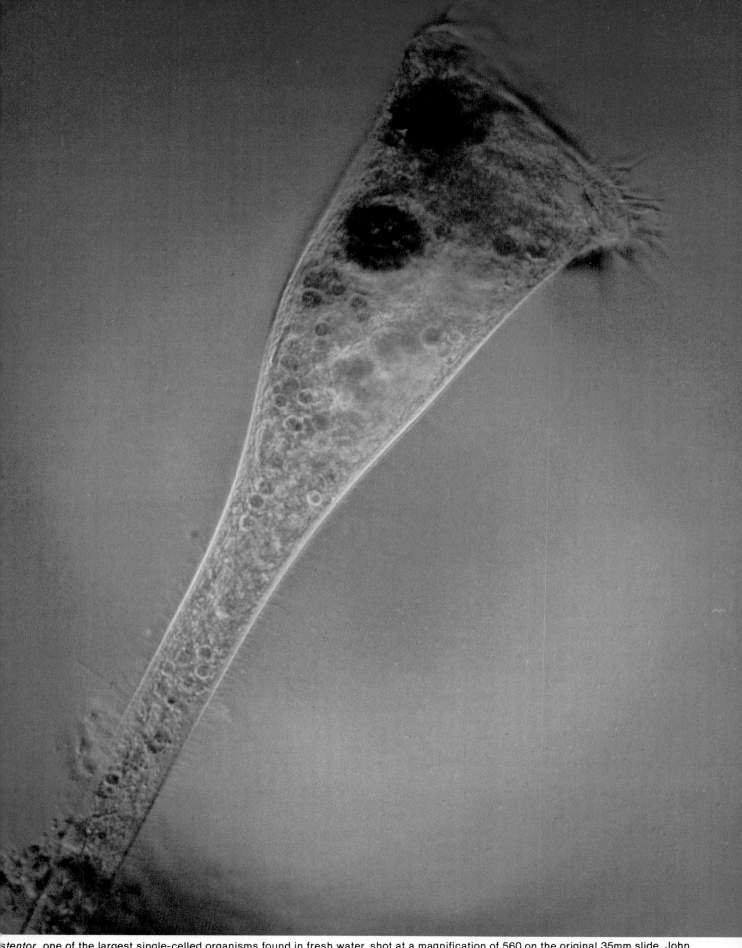

stentor, one of the largest single-celled organisms found in fresh water, shot at a magnification of 560 on the original 35mm slide. John
chieved the spotlight effect by defocusing an inexpensive, uncorrected substage condenser.

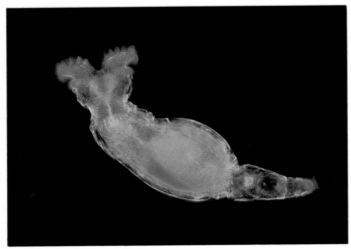

▲ *Philodina gregaria* is a *rotifer* found in the Antarctic. When photographed, this specimen had been frozen for two years. Magnification was 150. Darkfield illumination showed internal detail most clearly.

▶ The *brachionus* is a multi-celled creature a fraction of a millimeter long. The red spot is an eye. The trunk-like foot produces a cement that anchors the creature. Magnification was 175.

▼ This *trichocerca* is busy draining algae. The green inside it reveals earlier meals. Magnification was 250. As with the other two photos on this page, darkfield illumination clearly revealed internal detail.

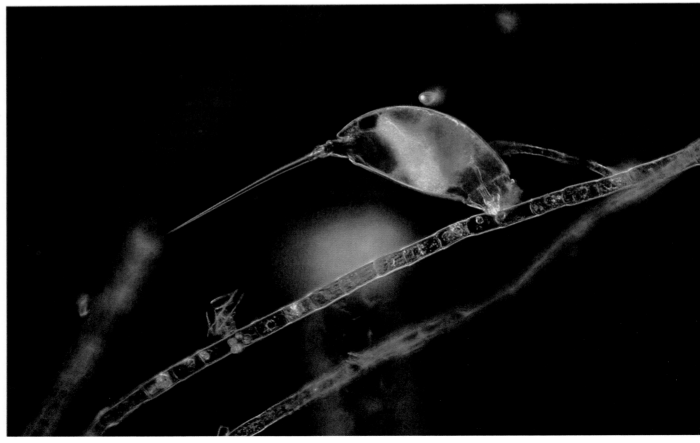

INDEX

Cover Photos:
Cactus Flower—Gill Kenny
Bread—George de Gennaro Studios
Locust—Hans Pfletschinger, Peter Arnold, Inc.
Back Cover—S.J Krasemann, Peter Arnold, Inc.

5.735930645530